ARTTAIWAN

THE CONTEMPORARY
ART OF TAIWAN

AN ART AND ASIA PACIFIC BOOK

THE CONTEMPORARY

ART OF TAIWAN

MUSEUM OF CONTEMPORARY ART, SYDNEY and

TAIPEI FINE ARTS MUSEUM

in association with

UNIVERSITY OF WOLLONGONG

EDITED BY NICHOLAS JOSE AND YANG WEN-I

GIB

GORDON AND BREACH, PUBLISHERS
G+B ARTS INTERNATIONAL

First published in 1995 by
G+B Arts International Limited
in association with the
Museum of Contemporary Art, Sydney

Distributed in Australia by Craftsman House,
20 Barcoo Street, Roseville East, NSW 2069
in association with G+B Arts International:
Australia, Austria, Belgium, China, France, Germany,
Hong Kong, India, Japan, Malaysia, Netherlands,
Russia, Singapore, Switzerland, United Kingdom,
United States of America

Published in association with The Contemporary
Art of Taiwan exhibition at the Museum of Contemporary Art,
Sydney March – June 1995 and subsequently touring
within Australia

ISBN 976 6410 21 6 (Hard-cover edition)
ISBN 976 6410 53 4 (Soft-cover edition)
ISBN 976 6410 69 0 (Taiwan edition)

Design Bybowra Design Group Pty Ltd
Printer South Wind Production Singapore Pte Ltd

Contents

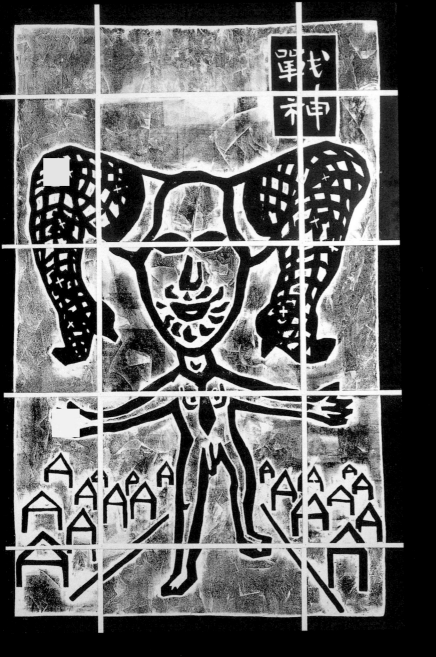

Foreword

by LEON PAROISSIEN Director, Museum of Contemporary Art, Sydney

Published on the occasion of the first significant showing of contemporary art from Taiwan in Australia, this book is intended as a timely contribution to the burgeoning of literature on the art of this region.

While governments and the business community have recently become acutely aware of the necessity of strengthening trade ties amongst countries of this region, Australians in general have had a long-standing interest in neighbouring countries and their cultures. In the case of Taiwan, however, different colonial histories, divergent shipping routes and, more recently, political shifts amongst major world powers have precluded the flowering of such close associations as Australia and Australians have enjoyed with other countries in the Asia-Pacific region. The rich multicultural fabric of Australian society contains a significant population of people whose origins lie in the People's Republic of China, Hong Kong or Taiwan and who will be immediately receptive to the work of artists represented in this book. Other Australians have travelled to Taiwan or would like to, while still others have no knowledge of this intensely interesting island other than the familiar 'Made in Taiwan' label on their diverse consumer goods, and this project will represent to them an extraordinary introduction to the visual culture of the country. Conversely, Australia is rapidly becoming a popular destination for travellers from Taiwan. It is hoped that this project, as the second part of an exchange of exhibitions, will generate interest in both countries and foster ongoing exchanges.

This book points out profound differences reflected in the visual cultures of the two countries. Yet certain parallels struck me during my first visit to Taiwan. While Aboriginal Australians have never had a sense that the origins of their culture and significant contemporary developments are to be found beyond the surrounding seas, successive waves of immigrants to Australia have lived with the idea that the richest cultural resources exist in distant, largely inaccessible countries. The development of the arts in Taiwan has occurred in the context of a comparable situation. In both countries recent decades have seen greater access to travel and information, and an accompanying self-confidence has emerged as artists move freely from examining issues in their own culture to harvesting ideas for their work from the great metropolitan art centres of the world.

Taiwan's specific colonial histories, and its geographic severance from the vast cultural resources of Mainland China, have no Australian equivalent. Yet Taiwanese artists have struggled, very much like their Australian colleagues, with complex issues of cultural identity and the relevance or otherwise of major developments in twentieth-century western art.

On behalf of the Museum of Contemporary Art, I would like to express my special thanks to Nicholas Jose, Deborah Hart and Janet Parfenovics, on the Australian side, and Dr Huang Kuang-nan, Director of the Taipei Fine Arts Museum and his staff, especially Pan Tai-fang, Yang Wen-i and Lin Ping on the Taiwan side. I would also like to thank Professor Ken McKinnon, (former Vice-Chancellor of the University of Wollongong), Professor Gerard Sutton (current Vice-Chancellor of the University of Wollongong) and Dr Peter Shepherd and David Chen for initiating this exchange and so enthusiastically supporting its realisation. Most importantly, I would like to offer special thanks to the artists and writers and I trust that their invaluable contributions will in future years be seen as the commencement of a most fruitful interaction between the cultures of our two countries.

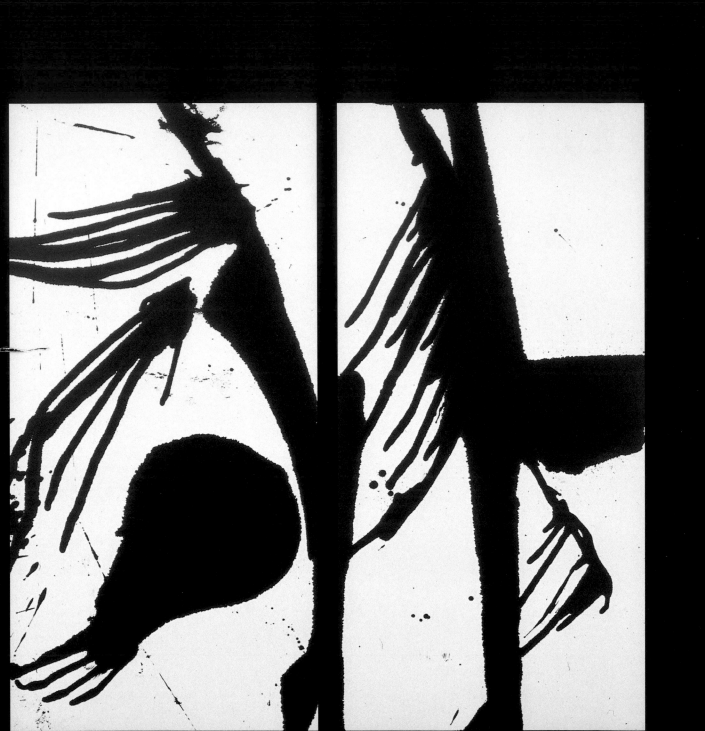

Preface

by HUANG KUANG-NAN Director, Taipei Fine Arts Museum

A rt represents the quintessence of human intelligence. Artistic creation, in all its traditional and emerging forms, contains and describes humanity's pursuit and sense of the higher meanings of life. In this day and age, absorbed in competition for the global market and stimulated by instant media communication, the essence of artistic creation, as a means for us to transcend reality with our soul and spirit, takes on even greater significance.

In the finest traditions of Chinese culture, art and aesthetics have enjoyed a long and fruitful legacy. The *yin-yang* duality of the *Book of Changes* and the universal view of unity between the heavens and humankind represented in Tang and Sung dynasty landscape painting, remain to this day within the Chinese collective cultural memory as the building blocks of modern artistic creation, which in turn have grown exponentially into a wellspring from which all artists seek and conceive their creative inspirations. Such balance of content and form, characteristic of the oriental natural organic aesthetic, stands in stark opposition to western dialectical reasoning and serves as a source of spiritual sustenance for today's Taiwanese artists.

The *Art Taiwan* project continues the Taipei Fine Arts Museum's efforts in recent years to position Taiwan art internationally. 'Identities: Art From Australia', conceived by the University of Wollongong, was held at the Taipei Fine Arts Museum from December 1993 to February 1994 to widespread and enthusiastic acclaim. In turn, *Art Taiwan*, organised by the Museum of Contemporary Art, Sydney and the Taipei Fine Arts Museum, in association with the University of Wollongong, presents a selection of contemporary Taiwanese art, concentrating on the work of some thirty artists, all born after the end of World War II. The focus is on painting, installation and ceramics; for reasons of space, traditional ink painting and sculpture have been omitted. Although it inevitably offers only one selection from the wide spectrum of present-day art practice in Taiwan, *Art Taiwan* is a major exhibition and, together with this publication, I am confident that it provides the finest introduction internationally to Taiwan's contemporary art.

This project would not have been possible without the tremendous support of the University of Wollongong and the University's Peter Shepherd (Associate Professor, Faculty of Creative Arts), and Deborah Hart (MCA Curatorial Adviser). In addition, Leon Paroissien, Director of the Museum of Contemporary Art, Sydney, General Manager Janet Parfenovics, and Curatorial Adviser Nicholas Jose, provided much-needed assistance and enthusiasm throughout the preparation period. We are especially pleased and grateful for all the generous support we have received from our counterparts in Australia's art museums in the promotion of contemporary Taiwan art. Vital support was also provided by Taiwan's Ministry of Foreign Affairs, Ministry of Education, the Council for Cultural Planning and Development, and the Taipei Municipal Government, as well as countless private individuals and organisations, especially those who went out of their way to lend us works and provide material for the preparation of this publication. Nor can the steadfast efforts of the entire staff of the Taipei Fine Arts Museum go without receiving their due mention.

Finally, I would like to add my best wishes for the continuing success of the project: may people respond warmly to *Art Taiwan*. I am sure that the success of the project will go far in expanding cultural exchange and enhancing mutual understanding between people in Taiwan, Australia and internationally.

Acknowledgements

This book is published as part of the project Art Taiwan at the Museum of Contemporary Art, Sydney. So many people have contributed to this complex and exciting project that it is impossible to thank them all adequately. Special thanks are due to the artists, galleries, museums, writers, collectors and other friends in Taiwan for their support and their generosity in making material and artworks available. Thanks are also due to Colin and Mary Heseltine and the staff of the Australian Commerce and Industry Office, Taipei; Neil Thompson, Manager, Qantas Taiwan; Johnson Chang Tsong-zung in Hong Kong; John Clark; Linda Jaivin; Tricia Lin; Hanita Schlick; Elizabeth Sullivan; the Taipei Economic and Cultural Offices, Canberra and Sydney; and The Independence Daily (Australia).

PROJECT COMMITTEE

Janet Parfenovics	Museum of Contemporary Art
Nicholas Jose	Museum of Contemporary Art
Deborah Hart	Museum of Contemporary Art
Yang Wen-i	Taipei Fine Arts Museum
Pan Tai-fang	Taipei Fine Arts Museum
Lin Ping	Taipei Fine Arts Museum
Peter Shepherd	University of Wollongong
David Chen	University of Wollongong
Dinah Dysart	Fine Arts Press
Hari Ho	Fine Arts Press

NOTE: In romanising Chinese and Taiwanese names and placenames we have tried to use the version in most common use, or preferred by the artists and writers themselves. Otherwise we have used *Hanyu pinyin*.

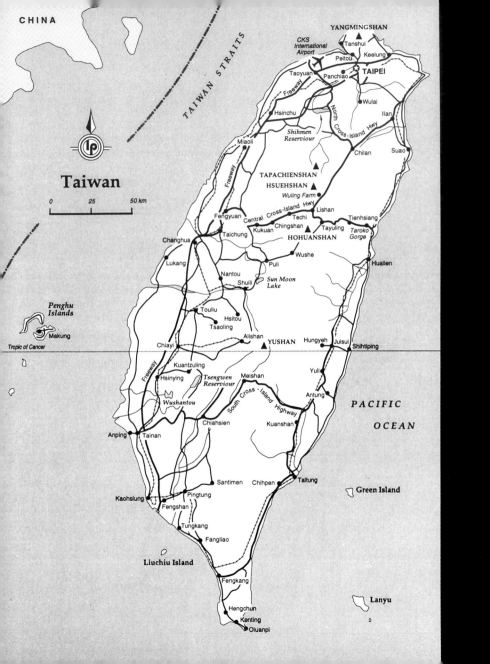

Timeline

The records of indigenous people inhabiting Taiwan date back at least 6,000 years.

15TH CENTURY People from Fujian in coastal southern China migrate to Taiwan.

1590 Portuguese sailors are the first Europeans to land on the island of Taiwan, which they name Formosa.

1622 The Dutch invade Taiwan and establish their capital at Tainan, where they build Fort Zeelandia in 1624.

1626 The Spanish occupy northern Taiwan, but are expelled by the Dutch in 1641.

1661 Ming loyalist Cheng Cheng-kung (Koxinga), fleeing the Ching (Manchu) takeover of the Chinese Mainland, expels the Dutch from Taiwan.

1682 The Manchu armies defeat the Ming regime, capturing Taiwan, and large-scale migration from Fujian province follows; Taiwan is administered as a county of Fujian province.

1860 Literati meet at Panchiao to discuss the future of Taiwan.

1865 Presbyterian missionaries first arrive in Taiwan.

1885 Taiwan becomes a province of China.

1895 Taiwan and the Pescadores islands are ceded to Japan after Japan's victory in the Sino-Japanese war.

1900 Societies are formed to preserve Chinese culture in the face of Japanese influence.

1911–12 The Ching dynasty collapses, and Sun Yat-sen becomes first president of the Republic of China.

1924 Taiwan Cultural Association is established.

1941 Japan attempts to mobilise Taiwanese as 'imperial subjects'.

1945 Japan's defeat in World War II sees sovereignty over Taiwan returned to (Nationalist) China, an event known as 'retrocession'. Mainlander Chen I becomes Governor.

1947 In taking over Taiwan, Nationalist (Kuomintang) Chinese authorities suppress an uprising by local Taiwanese (beginning 28 February) in which an estimated 20,000 people die.

1949 The Chinese Communist Party, under the leadership of Mao Tse-Tung, takes control of the Chinese Mainland; the Nationalist government, led by Chiang Kai-shek, retreats to Taiwan, which continues to be known as the Republic of China (ROC), claiming to be the sole legitimate government of China. One and a half million Mainlanders migrate to Taiwan at this time.

1960s Rapid industrialisation (with economic and political support from the United States and other western nations) launches the 'economic miracle'.

1971 Taiwan loses the China seat at the United Nations.

1975 Death of Chiang Kai-shek.

1978 Chiang Kai-shek's son, Chiang Ching-kuo, becomes president.

1979 USA transfers diplomatic recognition from the Kuomintang's Republic of China (ROC) to the Chinese Communist Party's People's Republic of China (PRC) as the 'one China'.

1984 Britain and China sign the joint declaration returning Hong Kong to PRC sovereignty in 1997.

1986 Democratic Progressive Party (DPP) and other parties form in opposition to the KMT, with some candidates successfully elected to the legislature.

1987 38 years of martial law come to an end.

1988 Death of Chiang Ching-kuo; Lee Teng-hui becomes the first Taiwan-born president.

1989 PRC authorities suppress a widespread protest movement in the 3–4 June Tiananmen Square massacre; democratic elections are carried out in Taiwan.

Taiwan Treasure Island

by NICHOLAS JOSE

Beautiful island. Lost paradise. Strongroom of Chinese treasure. Swashbuckling sentinel against Gargantua across the water. Mountain of gold. Dragon economy. Diplomatic orphan.

Contemporary art in Taiwan arises from a time and place intersected by contending historical narratives, geopolitical mappings and cultural affiliations, where nation-building strategies have succeeded chiefly in producing noisy dissent about what might constitute culture or nation. The society's storytellers – artists, writers and critics – project cacophonous, assertive, uncertain tales about themselves to a double audience of insiders and outsiders. While no individual artist's work can be categorised solely according to the place and time of its production, the art of contemporary Taiwan can nevertheless be grouped together under the banner of a twisting, fantastic and polemical set of stories, mutually dependent, mutually antagonistic, in which creative making is tied inextricably to specific, yet always disputed, circumstances.

Indigenous Taiwan, named Formosa, the Beautiful Island, by colonising Europeans, became the offshore refuge of Ming loyalists from southern China when the Manchus invaded the Chinese heartland from the north in the seventeenth century. Two centuries later the Manchu collapse, hastened by the depredations of Western powers, led to the Japanese occupation of Taiwan. The defeat of Japan in World War II brought Chiang Kai-shek's Nationalists to take over the island as a base for their claim to govern China. When the United States and other countries recognised the People's Republic of China in 1979, diplomatic isolation followed for the rival Republic of China and the quest for 'local soil' Taiwanese identity intensified. By the 1980s Taiwan had become an economic powerhouse in its own right,

following Japan to 'developed-nation' status, yet without Japan's strong national form. From 1987 Taiwan has pursued a rough-and-tumble democracy in which Nationalist rule has become less secure and the movement for 'independence' from Mainland China has grown. The Mainland Chinese Communist Party reserves the right to use force to 'recover' the renegade province of Taiwan, while the Nationalists on Taiwan sit prepared to wait for the collapse of the 'bandit' Communist regime across the straits before ultimately 'retaking' the motherland. Much of this must seem like a dream or nightmare to the majority in Taiwan who identify their long-term future as simply Taiwanese, and who realise that, if they are to have a future at all, the stories they tell must contain arguments for political, social, environmental and cultural transformation.

From early times, creative spirits in Taiwan have grouped together to make alternative blueprints to occupation, authoritarian assimilation or marginality, working obliquely in art and literature when to be explicit was impossible. 'What the artist felt, what the philosopher thought, and what the patriot dreamed of, were all put into song by the poet', writes one historian in reference to the dynamic role of literati gatherings in the evolution of civil society from late-seventeenth-century Taiwan onwards. In the late twentieth century, Taiwan artists, while jealous of their individual trademarks in the vigorously competitive critical and commercial marketplace, continue to position themselves in groups according to identifications of lineage, locality, training (including overseas experience) and ideology.

So, for example, the stories that artist Huang Chin-ho tells about himself and in his work are as pointed as they are entertaining. Born in 1956, Huang Chin-ho describes himself as thirteenth-generation Taiwanese, from a

An Introduction

family that migrated from Fujian in southern China 300 years ago – and perhaps with some Dutch blood. He speaks Taiwanese or *minnanyu*, the dialect of Fujian. He shares the distinctive, popular Taoist–Buddhist spirituality of Taiwan. In paintings such as *Journey to paradise* and *Garden of earthly delights* he draws on Taoist symbols and colours against a philosophical background of Buddhist detachment from material desires and physical passions. In Chiayi in west-central Taiwan, where Huang Chin-ho was born, the incoming Mainland Chinese Nationalists were especially harsh in their attempts to annihilate local opposition. The memory of the 28 February 1947 uprising and the subsequent White Terror, in which many thousands of people were killed throughout the island, was a catalyst for the development of Taiwanese consciousness among the population of the area

Huang Chin-ho was initially self-taught as an artist. Failing to get into art school, he studied philosophy and history, developing a special interest in Taiwan's history. Painting came later. In the early 1980s he was an abstract expressionist and in the later 1980s moved on to neo-expressionism; by 1989 he had achieved his ambition to work in New York. It was in New York, far from Taiwan, that he realised that the art he most passionately wanted to produce was inseparably bound up with Taiwan itself. In 1990 he left New York behind and returned to Taiwan to embark on his quest for a new, locally generated style. In a series of remarkable paintings from 1990 on, Huang Chin-ho has used local elements and materials to articulate a Taiwanese aesthetic that is different from China's and different from prevailing modes in the West. Part horrifying, part celebratory, these works show the newly prosperous denizens of Taiwan in a world of exuberant grossness and

■ *Tienhsiang Bridge, Taroko Gorge. Courtesy: Taipei Economic and Cultural Office.*

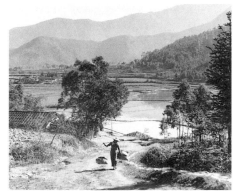

■ *Hedda Morrison Near Sun Moon Lake, 1960 gelatin silver photograph 32 x 27.5 cm. Courtesy of Powerhouse Museum, Sydney.*

garish transformation. Traditional symbols, such as peaches (for longevity), sugarcane (for good luck) and lotus leaves, jostle with the imitation-classical facades of karaoke bars and strip clubs in exquisitely painted garden settings where humble cabbage grows in the foreground and overweening powerlines soar behind. The artist talks of Taiwan's 'migrant' and 'colonised' culture as having produced a flamboyant, ostentatious aesthetic, a brash ersatz rococo which, for all its intense physicality, expresses the pathos of untrammelled or unachievable psychological and spiritual desires and states. Huang Chin-ho is engaged in a kind of striptease himself, peeling the clothes off his fleshy figures to show them empty of soul underneath, or lacking head and heart. In *Journey to paradise*, he seems almost to peel the skin off the famous singer who has ended up working the meat markets. Elsewhere he exposes the hybrids of a crossover society, pumped-up beasts in bikinis, robots with dictator faces, transsexual, hermaphrodite party animals all crossdressed-up with no place to go. In these wild, warning scenes, the artist is concerned with the meaning of Taiwan's history, the consequences (especially for the environment) of Taiwan society's materialism and pragmatism, and, fundamentally, with a contemplation of human existence in which the world of spirits hovers, perhaps trapped, within the fiery, brightly coloured world of passion and mortality.

Narrative elements are no less present in the work of other contemporary Taiwan artists, whether it is the retelling of political histories in the work of Wu Tien-chang, Yang Mao-lin and Mei Dean-e, the conversation pieces of Yu Peng, Cheng Tsai-tung and Lee Ming-tse, the fantasy illustrations of Hou Chun-ming and Lien Chien-hsing, the esoteric story-fragments of Chen Hui-chiao and Chiu Tse-yan or the Zen diary entries of Huang Hung-teh and Yen Ding-sheng. Johnson Chang Tsong-zung, one of the first observers to mediate Taiwan's new art for an outside audience, identifies the inscriptive impulse in a number of Taiwan artists as 'a continuous, often unconscious exploration of the self in relation to environment or family, as though the artists are unsure of their own "shapes" and need to define themselves through a re-constitution of a familial or environmental world'. Looking 'at Asian countries newly liberated economically', Chang sees 'a growing self-awareness. With this will inevitably come an art which attempts to re-align one's orientation in the world from an individual perspective. Speaking generally, the need for constant re-affirmation of one's local identity will also grow with an increasingly shifting, fast-moving world'.

In this sense, localism is also a global phenomenon, and Australians will readily find points of contact between Taiwan's cultural situation and their own. The comparison was not lost on the early historian of the island, himself an Australian, whose rhetoric transfers with prophetic quaintness to 1995, when Taiwan is Australia's sixth trading partner and tourist traffic between the two places approaches 200,000 annually, not to mention the host of other connections.

In *Formosa: A Study in Chinese History* (1966) W. G. Goddard writes of

a striking similarity between the making of this Formosan character and that of the Australian ... In both cases the toll of life and labour's enterprise was terrific ... In both cases another element, this time human, entered into the struggle to intensify it and add to the casualties ... Historians have recorded the lawlessness that resulted, but out of the struggle

... developed that spirit of independence and that love of freedom, so characteristic ... [and] also, perhaps, that resentment against authority.

This, of course, is merely another story. How later generations are revising it remains to be told. Now, at any rate, Taiwan's contemporary art can speak to us with surprising, if partially deceptive, directness. Its quite particular energies and exuberance are unexpected, fascinating, and perhaps, like the gilded temples that are sprouting like mushrooms all over the Beautiful Island, even inspirational.

■ *Nicholas Jose is Curatorial Adviser at the Museum of Contemporary Art, Sydney. A Mandarin-speaker, he was cultural counsellor at the Australian Embassy, Peking, from 1987 to 1990. He has published four novels and two short story collections. His most recent novel* is The Rose Crossing, *1994.*

■ *Artist Huang Chin-ho in Taichung. Photograph: George Gittoes.*

Transition and Re-Creation in

by YANG WEN-I

When I die, bury me between Yangtze and Yellow Rivers,
Rest my head, white hair covering black earth,
In China, most beautiful, most maternal of all countries,
That I may quietly sleep, sleep over the whole of China ...
<div align="right">(YU KUANG-CHUNG, 1966)</div>

Among the various overlapping and interwoven layers of culture in Taiwan, Han Chinese history and tradition claim the central position. This owes much to the wholesale transplantation of Greater Chinese culture to Taiwan by Chiang Kai-shek's post-war government, and the introduction of that culture into the educational system. In addition, Spanish and Dutch rule in the seventeenth-century, Japanese colonialism from the end of the nineteenth-century to the end of World War II, and large-scale American economic aid and military protection during the Cold War era have all left more or less recognisable imprints in the Taiwanese consciousness and cultural orientation. The 'economic miracle' achieved during the late 1970s and early 1980s gave the Taiwanese, on a psychological level, a tremendous amount of confidence and national pride. Subsequently, with the lifting of martial law in 1987, the emergence of a legal opposition party, and the constant reminder of China's ever-present threat to 'liberate' Taiwan by force, a new local ethnic consciousness was awakened and spread widely among the Taiwanese people.

This consciousness marked nothing less than a profound reflection on the existence of the self, and a confirmation of and investigation into the individual's own position amid rapid economic growth and gradual political liberalisation. How to extract southern Chinese characteristics contained in Taiwanese culture – such as vivacity, adventurousness, love of freedom, care for folk customs, and pragmatism – from the metaphysical concepts, abstract value system, and bureaucratic political institutions characteristic of Greater Chinese culture, has become an issue of personal concern to committed Taiwanese. Here, it is impossible to deny that the 'western model' has acted as an important contributing reference and catalyst, whether in politics, society, or culture.

Among contemporary Taiwanese artists, both Yang Mao-lin, an artist skilled at measuring the pulse of the times, who established himself in the politically turbulent years around the lifting of martial law in 1987, and neo-Dadaist and conceptual critic Mei Dean-e, offer different but equally thought-provoking views on the issue of cultural identity. In his characteristic symbolic and expressive manner, Yang Mao-lin combines fragments of ready-made historical images (such as maps of Taiwan, warships and cannon) with portraits of Cheng Cheng-kung, or Koxinga, and the last Dutch governor, Coyett (personalities who decided Taiwan's colonial fate among themselves) on either side of the canvas in the way ancestors were traditionally depicted (pl. 1). Above all, what attracts the viewer's attention is the fact that behind the image of Koxinga two cannon can be seen aiming at a map of Taiwan, resulting in a strong unmasking of the official transformation of Koxinga into a popular hero and of the brutal determination to refashion Taiwan's cultural make-up in the image of Greater China. The work can be seen as testimony to the rapid spread of local Taiwanese consciousness and the attempt to distance Taiwan from monolithic Chinese culture.

In contrast to Yang Mao-lin's search for Taiwan's historical roots, New York trained artist Mei Dean-e is concerned with the geographically and historically wider scope of Greater China. In *Silk Road* (pl. 8) he chooses

Contemporary Taiwan Art

one glorious achievement of Chinese civilisation, the invention of silk and its influence, as the subject through which to enter a dialectical conversation with the roots of Chinese culture. Like a natural scientist, he arranges a variety of two-and three-dimensional items, such as samples of natural objects, photographs and silk products, and re-examines both the metamorphoses of silkworms themselves, and their exploitation from the time of the Yellow Emperor to the modern age. He illustrates this display using examples from the fields of medicine, acupuncture, commercial life and geography. While the artist works in his customary meticulous fashion, as if engaging in scientific documentation, the Chinese title *Silk Road*, a pun on the words 'road of longing and sorrow', also evokes the nostalgic complex of searching for the lost dream of a Greater China.

Ku Shih-yung, moving between poetic worlds and dialectical conceptual art, proves himself to be a very sharp thinker. Trained in France, Ku makes expert use of photographic images. In *Home land, foreign land* (pl. 7) Ku combines these characteristics and for the first time addresses the problem of the transplanting of Taiwanese culture from the Mainland, to which he offers his own penetrating insight. Affixing at the juncture between wall and floor an enlarged photograph of waves rolling onto Taiwan's western coast, he has arranged thirty-two gilded Buddha hands (implying the thirty-two attributes of the Buddha), in gestures of blessing each ending in a sharp cone of fiery red, on the photographed seashore to achieve the effect of invaders from the sea landing on the Taiwan coast. The tension-filled treatment of materials and concepts (the realistic photography of scenery is contrasted with artificial culture in the form of gilded wood, or 'cultivated' reproduction) stresses the contrast between nature and human civilisation. The effect of this very

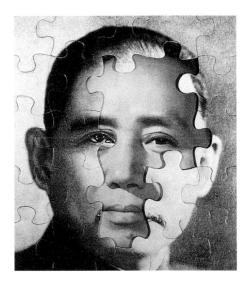

■ *Mei Dean-e*
Three Principles re-unite China, *1990*
photographic jigsaw puzzle, 85 x 100 cm.
Collection: Wu Ching-yu.

convincing treatment is at once poetic and disturbingly provocative. The message seems to be that Han Chinese culture occupies Taiwan under the disguise of a beautiful 'culture', as represented by thirty-two golden Buddha hands. Uncovering the true nature of this aggression is the critical objective of *Home land, foreign land*.

Among the din of criticism, one artist who, in contrast to those already mentioned, takes an actively positive stance and finds hidden treasures in long-neglected areas of traditional culture, should not be overlooked. Demonstrating an intimate familiarity with Chinese folk art, Kuo Jen-chang makes free use, in a heavily post-modern manner, of Chinese mythological subject matter and other images from traditional Chinese art. In *Day for night I-I* (1992) (pl. 11) the ancient myth of Kua Fu vainly chasing the sun is presented as a bold, fresh, brightly coloured new kind of Pop art which borrows the human forms characteristic of Han tiles and the thick, coarse lines typical of woodblock prints. In the legendary story of Kua Fu, as in the Greek myths of Phaeton and Icarus, the protagonist heroically challenges fate, only to meet a tragic end. Here, the infinite energy of primordial humans confronts the materialistic pursuits of today's decadent society. Kuo Jen-chang, characteristically combining the 'genes' of tradition and modernity and remoulding mythical legends, intelligently and exuberantly unearths the treasure of traditional Chinese culture from under the present.

Confucianism, Taoism and Buddhism remain deeply rooted and widespread among the people of Taiwan. Acknowledging this, while operating from different points of view, the artists introduced here use subversion, criticism and remoulding to create a dialogue with the sources and the evolution of Taiwan's culture and history. Yet in the field of traditional art other

inexhaustible resources exist which, through the long tunnel of time, exert a seductive attraction on today's Taiwanese painters. Literati painting has occupied a dominant position in traditional Chinese culture since the Tang and Sung dynasties, when painting began to be viewed as a communication of mental or moral feelings. The representation of the outside world, for a long time the standard by which western painting had been measured, was little appreciated and lightly regarded. Naturally, the subtle mysticism and complex interweaving of Confucian views on morality, aiming at transcending the phenomena of reality, Taoist feelings for emptiness and the other-worldly, and Buddhist, especially Zen-Buddhist, thought, with its pursuit of immediate enlightenment, acted as a net which dominated and controlled the literati's spirit and view of life for centuries.

At least three contemporary Taiwanese artists, Yu Peng, Cheng Tsai-tung, and Lee Ming-tse, regard artistic creation as an enrichment of life or a spiritual communication much as the ancients did. Of the three, Yu Peng, whose paintings are at once rich in imagery and almost childlike in execution, is certainly the closest to the sources of tradition. His point of departure is traditional painting, his favourite subject a transformation of traditional landscape and garden scenes. The aesthetic principles of Chinese painting, such as the use of multiple perspectives, the use of inked lines and chromatic shading, and an unadorned representation of human beings, are all contained in Yu Peng's works. Nevertheless, the brushwork of this artist, who is very much familiar with the tradition, often fails to follow academic rules, and is decidedly anti-traditionalist. The images that take shape in his paintings, such as steep, craggy mountain ranges and paradisaical worlds where

heaven and humanity are one, in reality are closer to the 'modern jungle' – the subtropical forests where nature and humanity are at once crowded together yet isolated from one another. In his recent work the attempt to transform the tradition is articulated still further. Oil painting replaces ink painting, a bold red and blue hint at a night scene, and in spite of the playfulness of female nudes, children, and garden scenes that are familiar from earlier works, in this modern–ancient painter's longing for bygone days an existential dilemma of coldness and alienation becomes apparent.

Cheng Tsai-tung, who established himself in the early 1980s using a western expressionist language to describe his own family experience, began around 1990 to shift his cardinal point of creativity in a direction opposite to that of Yu Peng; that is, from western modernism to tradition. Series like 'Nightlife in Peitou' or 'A Stroll through Taipei' bring to mind the nightly enjoyments and leisurely outings of traditional literati. By depicting modern scenes the painter alludes to the past, and at the same time projects onto it the 'Taiwan experience' of his own coming of age. It is also important to note that in Cheng's works the generally flat treatment of figures that seems to suggest isolated fragments, and the conflict and tension between those figures and their backgrounds, show very clearly this Taiwan-born, second-generation Mainlander's subconscious alienation and detachment.

Lee Ming-tse, who lives in southern Taiwan, is another enigmatic painter. Self-taught, he is inspired by traditional subjects and images, and his creativity sweeps over a broad range to encompass the lyrical, the humorous and the satirical as well as serious criticism of current issues and the revelation of the subconscious. He is a world apart from the linear discussion of a specified issue or from a circumscribed view of artistic creativity.

■ *Yang Mao-lin. Photograph: Chung Yung-ho. Courtesy of Free China Review.*

In his nostalgic imagery, where things past allude to things present, elements from traditional literati and popular culture such as ancient Chinese knights-errant, cartoon characters, classical young scholars, and beautiful women take the stage in turn. Through the vivid arrangement of the opaque colours he prefers, and unrestrained yet powerful execution, Lee Ming-tse has created an ambiguous world that combines the emotional with the intellectual and whose images are derived from widely disparate origins. His is a world that to a strong degree resembles the pluralist cultural background of the 'Taiwan experience' with its many different roots. No doubt this is a reflexive existential 'touch' on the part of the artist in response to oppression by a chaotic society.

The sunny skies of tropical southern Taiwan, the phoenix trees and temples that fill this cultural cradle, form a striking contrast to the competitive, alienating and fast-paced life of metropolitan Taipei and provide an ideal environment for artists like Huang Hung-teh, Yen Ding-sheng, and Lin Horng-wen to concentrate on the development of spirit and mind. The concepts of emptiness in Zen Buddhism, or return to nature and escape from the world, have provided the directions of the work of this group of outstanding abstract painters, based in Tainan, the ancient cultural capital of Taiwan.

Huang Hung-teh exhibits the closest affinity to Zen painting. Having developed his style independently during his early creative years in the 1980s, he has tentatively moved from acrylic to ink painting, while conceptually progressing towards an increased concentration and purity. In his series 'Magnet and Child' (1991) (pl. 15), Huang applies a base wash of yellow ochre that gives the effect of ink blotted on paper, in the traditional manner. Proceeding from this base, he applies swift, free brushstrokes that are simple yet potent.

Huang's artist's mind, brush and painting come together as a trinity that depicts the landscape of the artist's inner self. The aura of mystery and detachment from the world is reminiscent of an old monk in meditation or speaking a Zen koan. However intense and enigmatic, the painting at once reveals a childlike quality and a desire to return to the primordial simplicity and truthfulness advanced in the Taoist philosophy of Lao Tzu and Chuang Tzu. In short, here we confront an artist who ambitiously sets out to combine the traditional thought of Taoism and Buddhism in his painting.

Yen Ding-sheng typically spends some time each day tending to his flowers and practising calligraphy for his own edification. Hailing from a family of traditional herbalists, he possesses both the approach of the traditional literati and the demeanour of simplicity and candour typical of the south. Yen's early abstract paintings were heavily influenced by Yeh Chu-sheng, who returned from Spain in the early 1980s. Yeh spent a decade in Spain, where he developed a taste for Tapies's return to the material quality of the canvas and the relief-like application of colour. Through Yeh, interestingly, the characteristics of Tapies's painting that were themselves influenced by the mystical features of eastern thought returned to the East and became the point of departure for Yen Ding-sheng's own work. This 'Journey to the East', however, must eventually lead back to the real origins of these concepts, such as the thirteenth-century painters Mu Hsi and Liang Kai and the tradition of literati painting. In the works of the ancient painters, Yen Ding-sheng searches for a sense of the archaic atmosphere of the primordial state of the universe, and for the ambiguous relationships between those primitive plants or organisms. His paintings often mirror the poetic world of the soul, and describe inner lyrical emotions.

Lin Horng-wen is the youngest of this group. His range of style reaches from wild, floating, expressive abstraction to a return to quietude and emptiness, reflecting the unfettered thoughts and feelings of the poet–painter himself and the passionate ups and downs of his active inner state of mind. He, too, cannot avoid the magnetism of tradition, and favours the ink-painting technique of blotting to allow colours to flow and run into each other. Still, his works differ from Huang Hung-teh's quest for a Zen-Buddhist 'direct way to the heart' or Yen Ding-sheng's 'world of the mind'. Lin Horng-wen's colours and lines engage to a greater degree in an antagonistic dialogue with the materials themselves. His work with the pure material quality of the painting, rejecting figurative allusions or narrative explanations and his projection of his emotional state, strongly evoke the specific characteristics of this painter's poetic nature.

With the economic boom of the 1980s and the lifting of martial law in 1987, unprecedented disorder and chaos surfaced throughout Taiwan's politics and society. Traditional Confucianism, which relies on a monolithic set of moral standards to maintain absolute authority, soon yielded under the force of today's swift flow of information. On the other hand, as traditional agricultural society industrialised and demands for democratisation of the political system increased, a lack of suitable normative models became apparent, resulting in the emergence of a strongly polemic consciousness.

Shortly after martial law was lifted and authority began to disintegrate, Wu Tien-chang, in his characteristic polemic manner, created the startling series 'Portraits of the Emperors' (completed 1990) (pls 2). Nor could the timing of this historically significant series have been better. For the series the artist chose four political personalities, Mao Tse-Tung, Deng Xiaoping, Chiang Kai-shek and Chiang

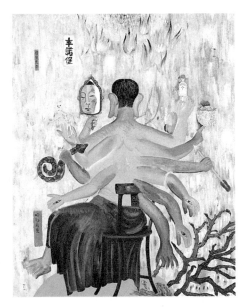

■ *Lee Ming-tse*
Jiu-Nuo Bao, *1992*
acrylic on canvas
117 x 91 cm.
Courtesy of New Phase
Art Space, Tainan.

Ching-kuo, whose influence on both sides of the Taiwan Strait has been crucial in the twentieth-century. Ironically using the traditional type of emperor portraits while also employing the traditional Chinese art of physiognomy, the artist's scrutiny of their biographies and their relation to Chinese history places them, as though biopsies, under a microscope. Showing the evil and horrifying faces of these 'Sons of Heaven' for whom human lives meant nothing, and revealing their feudalist and dictatorial character, the critical, sarcastic and deconstructionist intention of these works becomes fully apparent.

With the same powerful, precise and aggressive methods, Huang Chin-ho, a non-academic painter based in central Taiwan's Taichung, created the enormous painting *Fire* (pl. 3) in 1991–92. On a 4 x 8 metre canvas Huang depicts the substance behind the so-called 'economic miracle': a society out of control, dominated by greed and consumerism. Combining and mixing elements such as the instant 'European' architecture of karaoke parlours, the landscaping of Taiwan graveyards, and religious images like the Thunder God and Buddha, the artist uses dazzling, garish colours, merges the male and the female, the divine and the demonic, into one, and evokes robots to represent post-modern industrial civilisation and its materialism. The combined effect is that Huang strikingly taps into the hidden stream of consciousness of present-day Taiwan, a society whose values are empty and which has lost touch with its soul; thus the artist's allegoric admonition resembles a depiction of Hell. *Fire* is a masterpiece of recent Taiwan art that superbly captures the reality of current Taiwan society, reflecting Huang Chin-ho's strong social and political consciousness and his startling ability to transform and re-create received images.

Huang Chih-yang and Hou Chun-ming, two artists who completed their artistic education in Taiwan in the late 1980s, focus on the remnant moral values inherent in traditional Chinese culture, treating them as objects of criticism and satire. In Hou Chun-ming's *Erotic paradise* (pl. 12), in which the discussion of libido is combined with elements of folk culture, the traditional format of the picture book (text below illustration) is used forcefully yet humorously to satirise the Confucian view of sex. Traditional moral viewpoints, such as the conservative view of male–female relations which totally negates the sexual desires of human beings, are doubly lampooned, once in Hou Chun-ming's highly original pictures, and again in his text. Thus his works become a playground of absurdity. Sharp and poignant, they are also exceedingly funny.

Equally aggressive and subversive is Huang Chih-yang's series 'Hsiao Maternity Room' (pl. 27). The artist utilises traditional materials like ink, paper, line painting and the hanging scroll. But in Huang's works the Lilliputian scholar typical of classical landscape paintings has undergone a technological enlargement – a refashioning and ritualisation that turns him into a frightening skeleton. The title of this work combines the Chinese character for filial 'piety' (one of the highest of morals) with that for 'unfilial'. Using deconstructionist methods and subversion of tradition, Huang Chih-yang harshly criticises the fact that traditional morals maintain their grip on the minds and souls of today's population. At the same time he also mirrors the inner oppression which he himself confronts.

Having received artistic training in the United States and Germany, respectively, Lien Teh-cheng and Wu Mali each returned to Taiwan in the mid-1980s, where they began actively participating in exhibitions of social and political criticism around the time martial law was lifted. While Lien adopts Pop art as a medium of expression,

Wu shares the artistic and social views of Joseph Beuys. Subsequently, each artist has developed a distinctive personal artistic style and language. Lien Teh-cheng's works can be said to feature the dialectical interaction of Chinese characters, ready-made popular images and monochrome colour-field technique. Often the intellectual frame of these works is related to Derrida's deconstructionist theory that speaks of a 'dissemination' of language and script beyond their original meaning. In *News IV* which won a prize at the Taipei Fine Arts Museum's 1992 Biennial of Contemporary Art, three seemingly unrelated elements – the two Chinese characters for 'news,' a picture taken from woodblock illustrations of the classic novel *Romance of the Three Kingdoms*, and western geometric symbols – are brought together to achieve bold and creative new meaning. Thus the ubiquity of today's images, the questionable veracity of Taiwan's media reports, and the chaos of political struggles are conveyed in a subtle and indirect manner that nonetheless manages to hit the mark. In Lien Teh-cheng we have an artist who, from his perspective as a traditional intellectual, subverts the meaning of the written language and satirises traditional values; an intellectual critic who playfully uses conceptualist and deconstructionist methods.

Wu Mali's art contains similar characteristics and intentions, achieved through different means, such as collage and three-dimensional installations. In her *Prosperity car* 1993 (pl. 5), where the all-pervading status symbol (and the original Japanese brand name, which literally means 'to get rich quick') takes on an ironic twist, she uses ready-made materials such as wooden panels and car tyres, and covers her installation with golden paper and cloth to illustrate the money worship of the Taiwanese spurred on by the economic miracle. As the popular and profane image of the car becomes ironically 'sanctified' through the application of gold, the artist subverts conventional ways of thinking.

Another artist who makes use of the dually sacred character of gold (both in the religious and the profane sense) is Fan Chiang Ming-tao. Fan, who returned from the United States to Taiwan five years ago, began as a ceramic artist. After turning ceramics into a two-dimensional art, in recent years he has broadened his ambition, bringing ceramics into the realm of three-dimensional installation art. In his elegant *Dignity of green* (pl. 4) he arranges gilded clay blocks at the corners of the walls and floor. Situated in the middle of these blocks is a bed of young wheat sprouts. The fresh green of the plants, surrounded by the glittering of the gold blocks, shows the confrontation of two energy sources representing opposing value systems: artificial economics and materialism (gold), and the natural environment (green plants). Clearly, the sanctified status of the former, arranged in a nimbus-like pattern, also serves to glorify the greenery lying at its centre. Here, the artist has produced a ritualised and subdued work that indirectly criticises the excessive materialist trends of recent years, and ignorance of the environment and the destruction of ecology.

While there are quite a few outstanding artists in Taiwan who have employed satire, dialectics, or indirect criticism to address the political issues of recent years and the symptoms of a sick society, others have turned their attention to the changes in individual living space. With the rapid transformation of Taiwan society from an agricultural into a post-industrial society in less than forty years, lifestyles, whether in metropolitan areas like Taipei or in towns and villages, have undergone inevitable change. It is this issue that artists such as Lu Hsien-ming, Lu Mi, Chu Chia-hua, and Lien Chien-hsing

are concerned about and which occupies a central position in their creations.

Lu Hsien-ming, one of the central members of the strongly localist Taipei Art Group, has registered with uncommon sensitivity the changes that have transpired in his native Taipei during the last decade, such as the emergence of elevated highways, countless high-rise buildings, and the algae-like spread of mass rapid-transit-system construction sites throughout the city, above and below ground. With a sharp, detached, intellectual attitude, employing hard-edge form and thick layers of black, blue and grey, Lu depicts the empty, silent and frightening cityscapes of Taipei at night. His works, rich in symbols and hidden meaning, add the artist's own nightmarish interpretation of Taipei's ambitions to become an international metropolis. Not the least, Lu's works act as historic testimony to Taipei's tremendous metamorphosis in recent years.

Another member of this group, Lien Chien-hsing, is a native of Keelung, for which place he has retained a strong sense of affinity. Keelung was where French and Japanese troops entered Taiwan in the late nineteenth-century. Later it was the seat of Taiwan's largest coalmining region. This complicated historical background became the point of departure from which the artist began to work. Often, working from photos taken at various sites of local historical significance, Lien applies his skilful, realistic technique to transform the pictures into artworks that, nostalgic yet full of tension and suspense, comprise documentaries that fit the description of 'magical realist'. Under the artist's cool and rational treatment, however, rather than the beautiful scenery of bygone days, only pictures of memories that have lost their focus remain.

Kinetic artist Lu Mi, in his recent work *Wandering*

around the earth (pl. 6), surveys the ecological changes brought about as industrialised high-tech civilisation has replaced agricultural society. Choosing the image of the traditional courtyard where rice was dried in the sun and threshed, he alters it in two ways: the rice grains have become sand, and the people who would thresh the grain are replaced by a machine. Thus, not only are traditional agricultural activities declared dead, but calling the replacement of humans by machines 'progress' is criticised as being absurd. Furthermore, if we disregard the part of agriculture in our interpretation, this work can also be read as a prophecy of the ultimate destructive toll our high-tech civilisation takes on human culture and the natural environment, an elegy uttered in the present fin de siècle.

Immediately on returning to Taiwan in 1990 from studies in Italy, Chu Chia-hua set about creating humorous and satirical works in which new images are combined with patterned and decorative styles. Chu's bold and startling use of colourful manufactured patterns has drawn considerable attention in the art world. He openly embraces capitalist consumer commodities, using brightly coloured machine-printed cloth as 'canvas', in front of which he places giant high-class imported Steiff stuffed animals, including camels, bears and parrots (pl. 30). His works serve as a footnote to the excessive consumer culture of present-day Taiwan and the brand-worship of post-industrial city-dwellers. In today's highly critical, contemplative Taiwan art scene, Chu has found a new direction that is light-hearted and visually appealing.

The period from the mid-1980s to the mid-1990s symbolises the establishment of Taiwan art's international, diverse style. During the 1960s the rivalry between traditional ink painting and modernism (which at that time in Taiwan meant abstraction) became mired

in ideology and ultimately subsided for lack of interest. The 1980s, a time of rapid economic growth, saw the emergence of large-scale museum exhibition spaces, the return of many artists from overseas, and exhaustive coverage in local art magazines of international artistic trends, all of which enabled the art scene in Taiwan, previously limited to impressionism, surrealism and abstraction to link up with international art trends.

Among the group who returned to Taiwan in the early 1980s are Tsong Pu and Lai Jun-jun. Stressing to different degrees the essential qualities of matter and form (the former in the minimalist, the latter in the hard edge style), each has proceeded to a projection of the mind beyond the representational in search of pure art. However, since their return to Taiwan, a certain hidden collective memory of the East and local characteristics have progressively become manifest in each artist's work. Tsong Pu, who returned from Spain in 1981, became the undisputed winner of the Taipei Fine Arts Museum's 'New Trends' competition of 1984 with his *The trembling lines* (pl. 22). In this work we can already begin to see a minimalist form of expression reminiscent of the lines of Chinese calligraphy, particularly in the free style of 'conceptual script', and the use of stacked wooden boards and suspended wire. Thus, as assorted materials interact and mirror one another, an outstanding work in which a dialectic between eastern and western artistic languages takes place is achieved.

Lai Jun-jun ceased working in the hard-edge style around 1987. In her recent three-dimensional works she likes to convey images of nature and, through the arrangement of trees and stones, evokes and interprets the tranquillity of eastern gardens. Moreover, her works are executed with the diligence, exactitude and delicacy of peculiar observation specific to her female identity. Here depicting clouds, here offering a Chinese landscape,

■ *Downtown Taipei.*
Photograph: George Gittoes.

pure and concentrated like a short nature poem, her works are full of a light, spiritual atmosphere that floats before the eyes of the viewer.

Another minimalist artist whose creativity possesses the characteristics of female sensibility is Chen Hui-chiao. One of her series of works using needle and thread for the first time brings what have traditionally been female crafts – needlepoint and embroidery – into the realm of modern Taiwan art (pl. 21). In dazzling brightness, more than 10,000 silvery, glittering needles with silk threads attached to them, all in chaotic disarray, pierce pieces of polyester fabric layered on top of each other. The work provides an abundance of images and associations. In terms of form it is reminiscent even of Op art and minimalism, while in the application of thousands of threads it takes a traditional literary approach to describe the female heart.

Chen Hsin-wan, who comes from central Taiwan's Taichung, uses her strong and powerful creativity to project her restless energy through her art. Her neo-abstract works are mainly derived from the modern abstractionist school of the 1960s and 1970s and the new material art of the 1980s. Recently, sewed or pasted stripes of manufactured fabric or ink and paper have replaced the mixed media she employed in the past. In *In Search for life* (1992) (pl. 23), a series of abstract black-and-white paintings, she uses traditional Chinese ink, in a bold and straightforward manner reminiscent of automatic painting and full of organic vitality, to create an image of the innate dynamism of life.

Ink and paper are also the media Chang Yung-tsun employs for his neo-abstract art. In the 1980s he freely applied ink on long webs of paper and suspended them down to the floor in distinctly avant-garde installations. Subsequently, in his series *Transformation and installation of a changing melody* (pl. 26), he applied the traditional technique of ink dots on webs of rice paper, wrapping them into rolls with the inner layers torn upwards to achieve the conical form of a pencil point. Next, he placed them in plastic boxes and hung them on the wall depending on available space. His minimalist treatment of traditional media as basic materials is a strong gesture to convey familiarity with his own tradition and the intention to preserve it through contemporary art.

Yan Ming-huy is a practising feminist who uses bold and striking images to confront issues of sex and subvert traditional sexist oppression. Her two-dimensional allegoric and symbolic works often assume the form of still lifes but are in fact very provocative statements of the artist's feminist views: they feature flowers, vegetables, or fruits which are either enlarged or endlessly repeated to cover the whole canvas, in the former case representing the vagina, and in the latter denoting the dangerous crisis brought about by the oppression of women. Outwardly, Taiwan appears to be open and pluralistic, but as far as relations between the sexes are concerned, it remains a very conservative society. In this respect, Yan Ming-huy deserves credit for her pioneering, aggressive attitude in the cause of women's liberation.

Chiu Tse-yan, who returned to Taiwan from New York in 1991, chooses a creative direction completely different from that of Yan Ming-huy: a soul-searching, individualist journey. In her series of charcoal drawings on the animal soul she applies a delicate and refined touch to an almost existentialist, poetic and allegoric study of today's alienating and heartless society. In her isolated, endless and barren nightscapes, devoid of any human beings, only a lost dog is discernible, helplessly wandering around. Thus the work becomes a hidden yet

striking allegory of the rootless modern soul, ever in search of a meaning for existence.

A Taiwanese artist whose life and art are filled with feminine consciousness is Hou Yi-ren. Wandering like a guerrilla, she has taken on a number of current socio-political issues, ranging from ecology to party politics and democratisation, the dialectics of traditional thinking, and the world of her own upbringing. In *Wommunism* (pl. 24) the artist boldly and strikingly questions the traditional role of women as a vessel of inner beauty (represented by roses) and outwardly motherly duties (bowls). Through the dialectical relationship between form and content she persuasively channels feminism into the ideology of political strife represented by the five-pointed star symbolic of 'defunct communism', which is to be superseded, in the artist's eyes, by 'Wommunism'.

Another artist whose socially-oriented approach makes clear her feminist consciousness is Margaret Shiu Tan. In her early works Shiu Tan, who worked as a ceramicist for ten years, often applied clay slabs to two-dimensional surfaces as in relief, concentrating on the subject of clouds floating in the sky. In the thin, grey, and glossy glazed ceramic pieces she placed in black boxes, romanticism, softness and an unusually close observation of nature cannot be overlooked. More recently, she combines ceramics with installations or performances, and has abandoned her former focus on her self in favour of an almost maternal commitment to society. In her worlds of little ceramic people, such as *Floating* (pl. 19) or *The old ladder*, she depicts the social majority in miniature by transforming traditional moral sayings like 'Even if you grow out of dirty mud, be not soiled' in the former work, and admonitions, – 'Climb the social ladder step by step, leaving pursuers behind' – in the latter. However, given her sweeping view, and her clear appeal

to children to participate in the creation of her recent work, it might not be too far-fetched to assert that a traditional matriarch's role is carried over through the general concern that runs through her work.

A high degree of female consciousness and its firm position in contemporary Taiwan cannot be denied. However, in our discussion of the relationship between feminism and female artists, we should not neglect to mention that apart from Chen Hsin-wan, who has lived in France since 1992, and Chen Hui-chiao, who resided in France for just six months, the other six women artists have all lived abroad for five to ten years. What does this signify? Having experienced 'otherness' and contact with another culture, they have found their own means of artistic expression and not the least their self-consciousness as artists in the contemporary world.

Through their differing styles, subject matter and conceptual approaches, each of the Taiwanese artists introduced in this essay has sent out a very personal view of Taiwan and its intellectual environment, whether through the signification via transformation of western forms and symbols, or through refashioning, rearranging and remaking different artistic styles. By virtue of their unique artworks, the diverse, ambiguous, and multicultural historic background of Taiwanese culture has come to bear witness in this fin de siècle.

TRANSLATED BY
Klaus Gottheiner and David Toman.

■ *Yang Wen-i is Assistant Researcher at the Taipei Fine Arts Museum. Born in Taipei, she graduated from the Chinese Culture University, Taipei, and with an MA in European and East Asian Art History from Heidelberg University. She curated the exhibition 'Taiwan Art, 1945–1993'.*

A Brief History of Art in Taiwan

by WANG HSIU-HSIUNG

When Han Chinese began migrating to Taiwan, most of the population was engaged in agricultural pursuits. Whether they worked wet or dry fields, the people were well versed in fertilisation and crop rotation methods. Moreover, they exploited animal labour (oxen) and other power sources, such as watermill irrigation systems. The combination of fertile soil, favourable climate, and industrious farmers resulted in rapid rises in crop production. With the increased production, processing and trade of typical Taiwanese crops such as sugar cane, tea and camphor living standards reached a comfortable level and villages gradually developed into towns and cities. Only when physical and basic material needs are taken care of do people begin to look further for spiritual satisfaction. During the late seventeenth and early eighteenth centuries, members of the upper class, including large landowners and the gentry, were the first to take an interest in cultural and artistic activities. Two hundred years passed between this first spark of interest and the relinquishment of Taiwan to Japanese rule. What follows is a summary of the distinguishing characteristics of painting in Taiwan during this time.

While Taiwan was materially sparsely equipped during its early development, anyone with the scholar's basic writing tools could practise art. For this reason, the early development of painting in Taiwan tended towards plain literati painting in the most easily learned way. Of the extant paintings by Taiwanese artists of the period, the majority are freehand ink paintings and detailed realistic paintings executed in colour.

Freehand ink paintings of flowers and birds (featuring the four gentlemen: plum, orchid, bamboo and chrysanthemum) predominated, followed by portraits. Landscape paintings numbered the fewest. Such examples show that flower and bird ink paintings constituted the mainstream of literati painting, most likely a preference influenced by tastes in Mainland China.

The Taiwan portrait tradition was handed down largely via painters from Fujian. Huang Shen was one of the famous Yangzhou Eight. His characters and flowers, executed in rhapsodic brushstrokes, had a great impact on artists in both Fujian and Taiwan. Landscape painting of the Ching dynasty was dominated by the Four Wangs school, whose style is still held up as the standard for today's Taiwanese landscape painters.

The Treaty of Shimonoseki, concluded between the Ching court and Japan on 17 April 1895, ceded Taiwan to Japan. Building on the foundation established by Liu Mingchuan, the Japanese took the development of Taiwan to a new stage. First, the Japanese completed a land survey outlined but never completed by Liu Mingchuan. Begun on 5 September 1889 and concluded on 31 March 1915, the project doubled the area of taxable arable land, expanding the tax revenue pool. The Japanese took a double-edged approach to their colonial rule of Taiwan, adopting a strategy of accommodation towards the landowner and gentry classes and intimidation towards the working class and peasantry.

The first period of Japan's fifty-year rule over Taiwan (1895–1945) was largely spent in establishing public order (pacifying resistance movements throughout the island) and conducting economic development projects designed to complete the basic infrastructure necessary for a modern society. The second half of the five-decade Japanese reign concentrated on cultural development. The officially sponsored Taiwan Art Exhibition of 1927 was a watershed in the history of Taiwanese art. The successive annual staging of the Taiwan Art Exhibition

to 1945

promoted the germination and development of modern Taiwanese art, and helped bring an end to the conservative era which belonged to the literati painters while, in contrast, the latter half of the period (1927–45) can be thought of as the embryonic and developmental stage of modern Taiwanese art.

The influence of Ching period painters continued to hold sway over the art world during the first half of the Japanese period and, with the increasing acculturation of society, the literati painting style became more firmly established. Noted flower–bird painters included Hong Yongping, Zhu Shaojing, Cai Wenhua, and Lu Bisong; distinguished portrait painters included Fan Yaogeng, Lin Tianjue; and prominent landscape painters included Lu Bisong and Zheng Kunwu.

Yet this situation changed during the latter half of the Japanese period, as the Japanese became champions of modern Taiwanese art. Intent on raising the general calibre of the working and farming populations, the Japanese undertook the establishment of many schools and instituted a six-year mandatory education system. During this time they also took active steps to cultivate qualified native Taiwanese elementary schoolteachers. Early teachers' schools were known as national language schools, but later became known as normal schools. Once the six-year mandatory education system was firmly established the Japanese began establishing middle schools and various vocational schools and universities to train doctors, lawyers and technicians. Japanese art teachers at normal schools and middle schools acted as the champions of modern western art in Taiwan. Noted teachers of western-style painting included Ishikawa Kin'ichiro and Shiozuki Touho, while the most influential teachers of Japanese-style art were Gohara Koto and Konchita Seigai.

■ *Lee Ming-tiao*
Pedalling the water-mill
1948, fibrebase paper
40.6 x 50.8 cm.
Collection of
Taipei Fine Arts Museum.

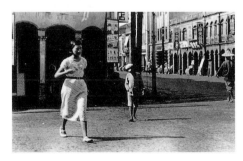

■ *Teng Nan kuang*
Taipin Ting, Taipei III
1942, fibrebase paper
40.6 x 50.8 cm.
Collection of
Taipei Fine Arts Museum.

■ *Ishikawa Kin'ichiro*
Formosa, *1930*
watercolour on paper
45 x 38 cm.
Collection of
Taipei Fine Arts Museum.

Thus western art came to Taiwan by way of Japan. Consequently, the Japanese methods of art education and the style of officially sponsored art exhibitions had a strong impact on western-style Taiwanese artists and on the tenor of the Taiwan Art Exhibition. Representative Taiwanese artists of this period all studied painting at the Tokyo Fine Arts Academy. The academy's western painting department, founded in 1896, was first chaired by Seiki Kuroda. The plein-air style, a compromise between the academy school and impressionism brought back to the academy from France by Seiki, set the tone for the teaching approach of the Tokyo Fine Arts Academy's western painting department, and dictated the western painting style of art exhibitions sponsored by the Japanese government.

One outcome of Japan's unfortunate participation in World War II was the great influx of new and democratic ways of thinking into the country. With such thinking, first fauvism, then cubism, and futurism were introduced to Japan, where they exerted tremendous pressure on the plein-air school, and moved Japan towards a style of local interest and personal expression.

The period when Taiwanese artists studied in Japan and the Taiwan Art Exhibition was begun coincided with an interest in democratic thinking in Japan and the early reign of Emperor Hirohito. Given these factors, it was only natural that these creative currents of the Japanese art world would be imitated by Taiwanese artists and the Taiwan Art Exhibition. For example: Lee Mei-shu and Yan Shui-long, who tended to depict Taiwan's distinctive landscape and customs, and Liao Jih-chuen and Chen Cheng-po, who explored an interest in Taiwan and in individual style.

The Taiwan Art Exhibition was held ten times between 1927 and 1936. Traditional literati style works were completely shut out of the first Taiwan Art Exhibition. Only the works of Guo Hsueh-hu, Lin Yu-shan and Chen Chin (known as the three youths of the Taiwan Art Exhibition) and Chen Hui-kun were selected. Their variety of Japanese painting was characterised by detailed observation and execution featuring the rich use of colours to realistically depict the face of natural and human life. Subsequently the work of other Japanese-style artists succeeded in reflecting local colour.

The majority of the works featured in the western painting section of the Taiwan Art Exhibition were executed in the plein-air, post-impressionism, fauvist and expressionist styles. A high proportion of prize-winning artists in successive years of the Taiwan Art Exhibition and Taiwan Governor-General Art Exhibition had received training in Japan, which in turn helped to contribute to the reflection of their styles in the Taiwan Art Exhibition and the Taiwan Governor-General Art Exhibition. Tokyo Academy of Fine Art graduates, such as Yan Shui-long, Lee Mei-shu and Li Shih-chiao, generally worked in the plein-air style or a style somewhere between the plein-air and Impressionist styles. However, other academy graduates, among them Chen Cheng-po, Chen Chih-chi and Liao Jih-chuen, produced highly individual works in styles ranging from post-impressionism and fauvism to expressionism.

Generally the works of Taiwanese graduates of the Tokyo Fine Arts Academy were richly individualistic. Right from the start, artists such as Yang San-lang, Liu Chi-hsiang, and Hung Rui-lin executed works in impressionist or fauvist style characterised by strong feeling achieved via distinctive brushwork and expressive use of colour. Local flavour and personal expression are exemplified in the works of such artists as Lan Yin-ding and Chen Chin-fen. The works of such artists as Chen

Cheng-po combined the qualities of Japanese and western styles, capturing the essence of literati art. The success of the Taiwan Art Exhibition and the Taiwan Governor-General Exhibition lay in the creation of numerous works abounding in Taiwanese feeling to impart a strong local flavour and style.

TRANSLATED BY
David Toman

■ *Wang Hsiu-hsiung is a Professor in the Department of Fine Arts and Graduate Institute of Fine Arts, National Taiwan Normal University.*

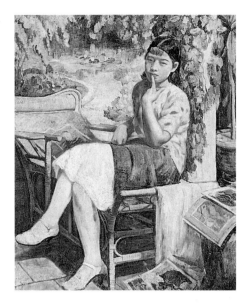

■ *Lee Mei-shu*
Girl taking a rest, *1935*
oil on canvas
162 x 130 cm.
Collection of Lee Mei-shu
Memorial Art Museum.

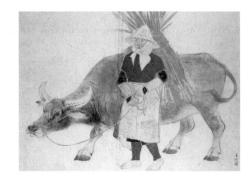

■ *Lin Yu-shan*
On the way home, *1944*
colour and ink on paper
154.5 x 200 cm.
Collection of
Taipei Fine Arts Museum.

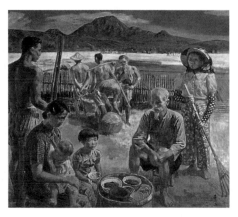

■ *Lee Shih-chiao*
Happy farmers, *1946*
oil on canvas
157 x 146 cm.
Collection of
Taipei Fine Arts Museum.

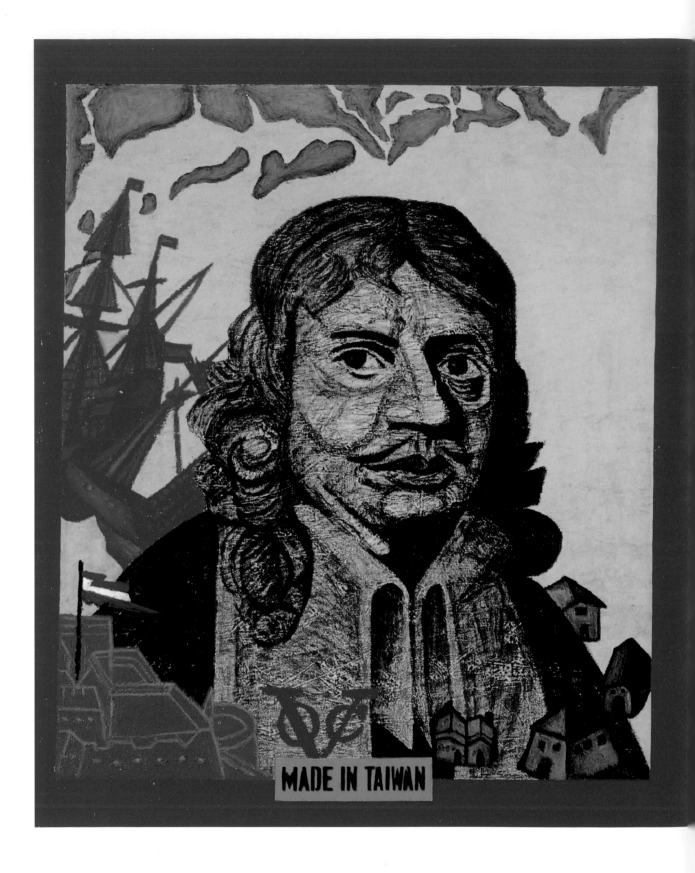

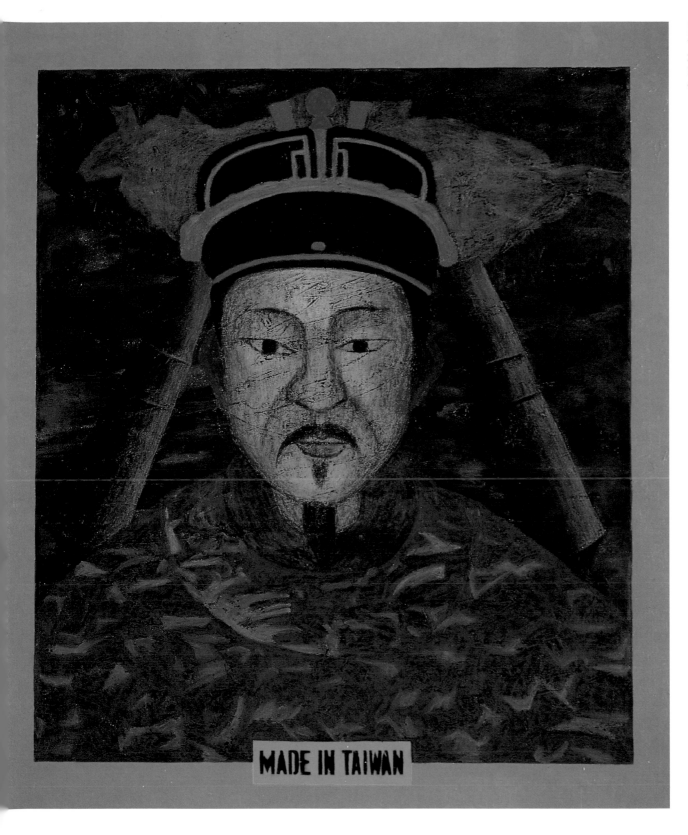

1
YANG MAO-LIN
Zeelandia memorandum
L9301, 1993
oil and acrylic on canvas

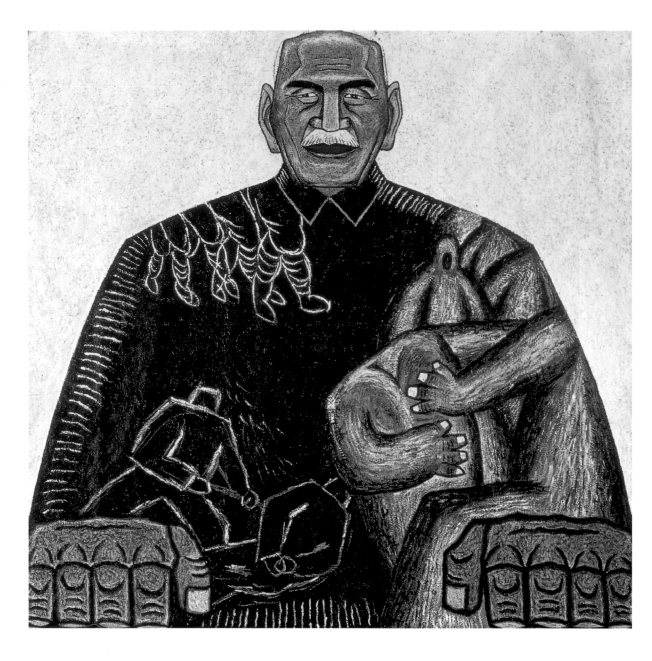

2

WU TIEN-CHANG
About the government of
Chiang Kai-shek, 1990
('Portraits of the
Emperors' series)
oil on linen

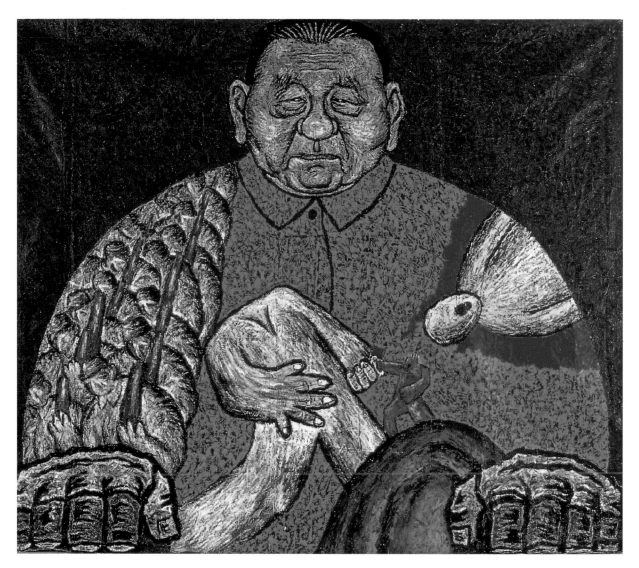

WU TIEN-CHANG
**About the government of
Mao Tse-tung, 1990
('Portraits of the
Emperors' series)**
oil on linen

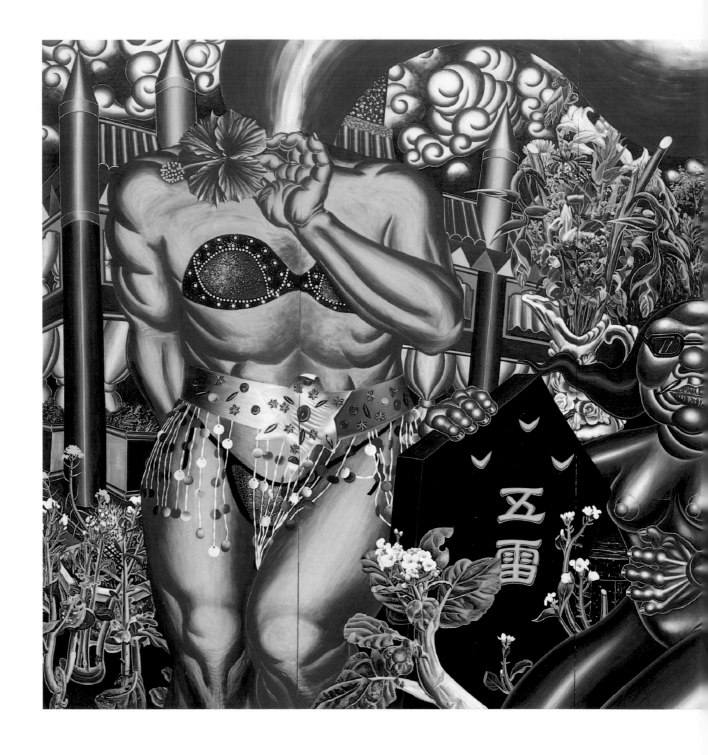

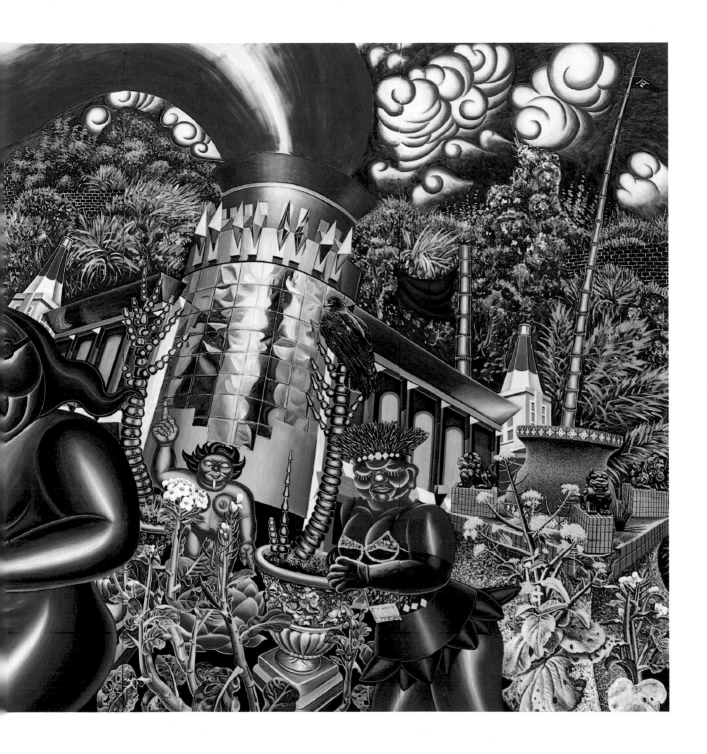

4

FAN CHIANG MING-TAO
Dignity of green, 1993
gilded ceramics, grass

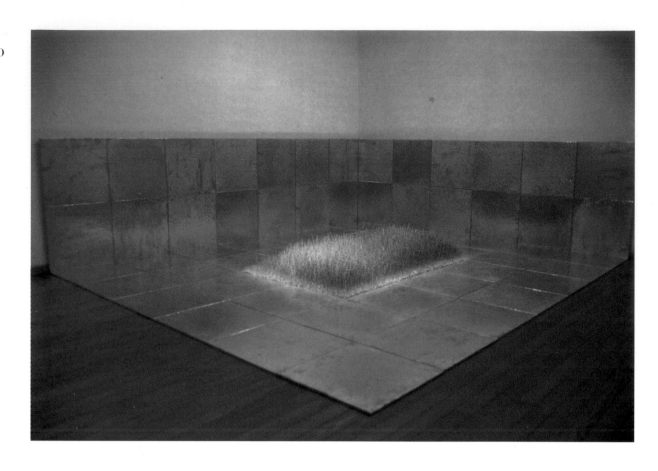

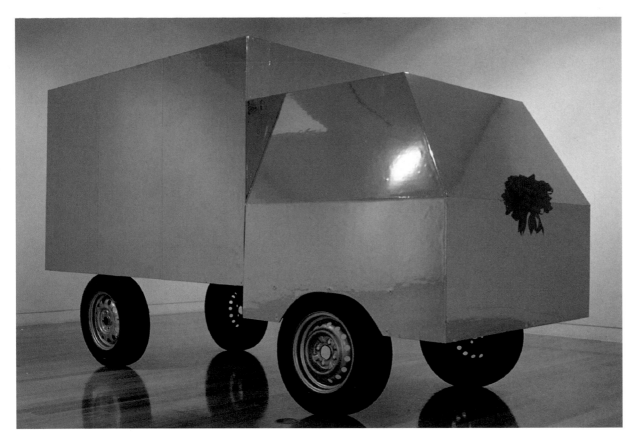

LU MI
Wandering around the earth, 1993
mixed media installation

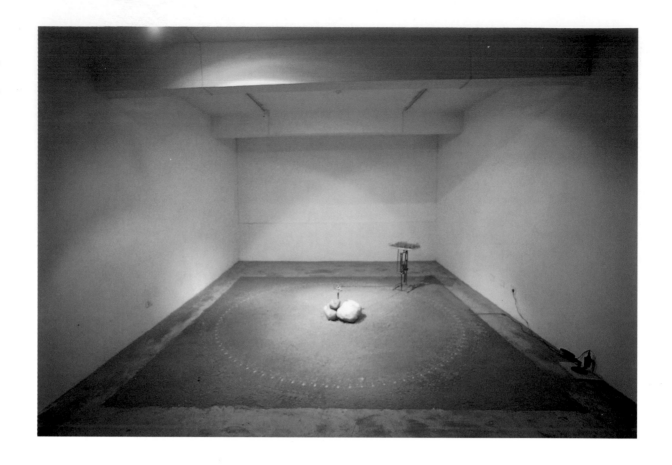

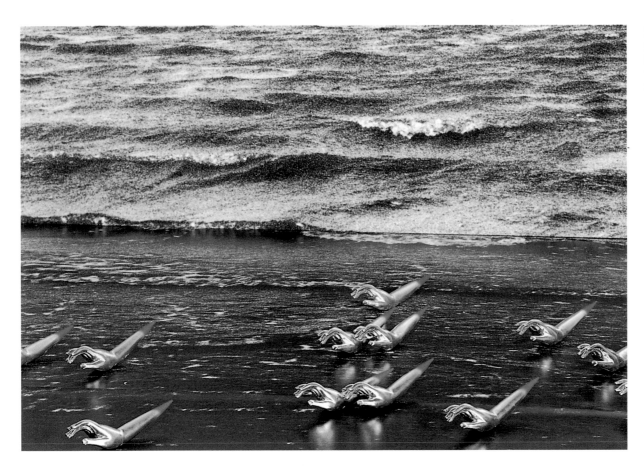

7
KU SHIH-YUNG
Home land, foreign land, 1993
mixed media

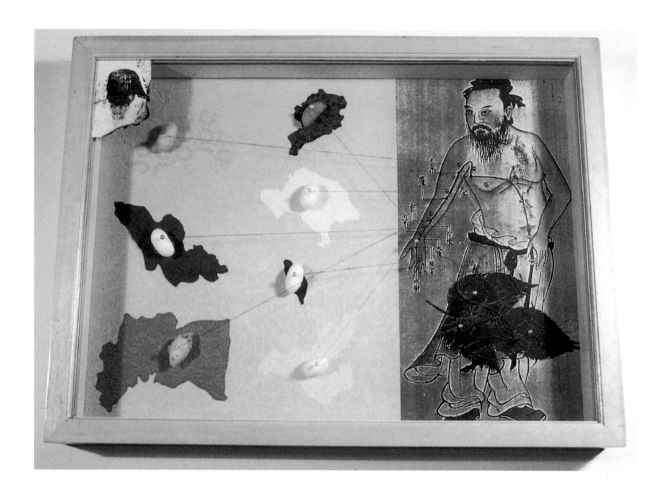

9
LU HSIEN-MING
Morning in Taipei, 1992
oil on linen

LIEN TEH-CHENG
Confucius says, 1992
mixed media

11
KUO JEN-CHANG
Day for night I-I, 1992
acrylic on canvas

Art in Taiwan 1945–95

by LIN HSING-YUEH

The Japanese defeat in 1945 brought to an end that country's colonial rule over Taiwan. At the same time it also ended the Taiwan fine arts movement as driven by the Japanese cultural juggernaut and thrust the island into a long era of control under the Nationalist or Kuomintang government from China, during which period dramatic political, economic and cultural changes swept the reluctant island.

With the outbreak of the Korean War in 1950 the United States radically altered its Far Eastern policy. Intent on containing the threat of the communist alliance headed by Moscow and Peking, the United States despatched its Seventh Fleet to the Taiwan Straits to safeguard Taiwan and incorporate it as a strategic base in a chain of islands stretching from the Aleutians in the north to the Philippines in the south. These changes in the face of the Pacific region set the stage for Taiwan's post-war era.

The Nationalist government brought to Taiwan an influx of immigrants fleeing communist rule over China. The historical and cultural perspectives and the lifestyles of these immigrants vastly differed from those of Taiwan's earlier inhabitants, thus sharply altering the island's social atmosphere. Apart from declaring martial law in an effort to shore up its tottering rule, the Kuomintang government exercised control over education and thought, regulating the extent to which the Taiwanese could stretch their cultural imaginations. This in turn allowed the conservative patrons of traditional ink painting to descend on Taiwan's educational and artistic order as the officially sanctioned fine arts orthodoxy.

The alteration of the political order after the war had a dramatic impact on social and economic structures. Land reform and industrialisation in particular undermined Taiwan's established agricultural society and brought about the demise of the landed gentry. The commercial clans and new middle class which rose in its place were too consumed with quenching material thirsts and accumulating wealth to devote any time or energy to art. Given the overwhelming emphasis on defence and economic development, distribution of national resources was sorely imbalanced, forcing meaningful cultural creation to endure a long and bitter winter which began a gradual thaw only in the late 1970s.

At the same time the tidal wave of American influence which crashed over Taiwan after the war cleared the way for a rush of new western art into Taiwan. Modernism, specifically the abstractionism that held the western art world in its grip at the time, thus hit Taiwan with tremendous force, more or less setting the direction for modern art in post-war Taiwan.

THE 1950s

Taiwanese art during the Japanese period included watercolour, oil painting and gouache painting. The early 1950s saw a brief return to prominence of artists who had exercised some influence before the war. In the context of the new era they eventually revealed their limitations. Generally speaking, their creative concepts and technical approaches were inspired and formed by Japanese models of fine arts education, traceable back to the Ecole des Beaux-Arts in Paris and official salons of the late nineteenth-century. Taiwanese artists who made names for themselves during the Japanese period learned and grew within the Japanese system. Their creative process involved openly embracing rigorous basic training, and proceeding from a studied grasp of realistic sketchwork with natural themes to lifelike pastels. In this way they could make appropriate use of such datums of

realism as the outlines of objective forms, lighting, textures and spatial relations to articulate complete pictures built with such personalised compositional elements as colour, brushwork and texture. These methods were reinforced by a sense of systematic progress and honed in major official competitions.

Modern western art, introduced by way of Japan, brought about a pre-war painting revolution which rapidly displaced the ink-monochrome painting order inhabited by Mainland Chinese scholar–artists. Western art inspired Taiwan's artists to use the earthy language of realistic painting in a dialogue with their own land. Depicting the daily scenes of people's lives, their works were populated with water buffalo, shepherd boys, farmers, village women, indigenous people, and the subtropical country landscape. This new direction displayed a Taiwanisation of western art in which Taiwanese artists achieved a rich portrayal of Formosa's land and people through their work.

With the clampdown on information under martial law, introduced in 1947, the White Terror which enveloped the island in the aftermath of the 28 February Incident, in which KMT Mainlanders assassinated many thousands of their Taiwanese opponents, and the subsequent official Mandarin involvement in cultural affairs, the voices of post-1949 arrivals to Taiwan eventually overtook those of the native Taiwanese. The artistic elite of Mainlanders did everything they could to consolidate the leading role of the conservative Greater China ink-monochrome painting order in Taiwan.

There were, however, those people in the art world who directed their energies towards expanding the room for creative possibility outside the established order. They broke new ground in the advancement of theory and in the work they produced, and had a far-reaching impact

Cheng Sang-hsi
In the rain, *1964*
fibrebase paper
40.6 x 50.8 cm.
Collection of
Taipei Fine Arts Museum.

Indigenous peoples of
Taiwan: Ami men wearing
turbans. Early 20th century
photograph from the
collection of Segawa Kokichi.
Courtesy Shoto Museum of
Art, Tokyo from the
catalogue Textiles and
Accessories of the Indigenous
Peoples of Taiwan, *1983*

on the younger generation of artists who worked with them. Nevertheless, it took until the late 1950s, when the anti-traditional new generation resorted to organised action, to shake the conservative order.

ARTISTIC REVOLUTION

In the late 1950s American influence spread through political, military, economic, social, educational, commercial, entertainment and mass media channels to reach every facet of life, exerting the greatest force on a new post-war generation wrestling with ennui and seeking the means to break free of their underdeveloped condition. As they took to western trends they began forcefully to condemn local tradition. They rejected out of hand the teachings of their elders and the strictures of the academies, and put their energies into new concepts that violated the convention of realistic execution of natural themes, and went against the grain of the idea of tutelage long stressed by the ink-monochrome school of Mainlanders in Taiwan. A sizeable generation gap thus arose.

Progressively minded artists, whose works were left out of officially sanctioned exhibitions, banded together for an audacious theoretical assault on the conservatives. They transported Taiwan's fine arts movement into an era of burgeoning popular interest in painting. During the 1960s, seventeen private art groups were formed in Taiwan, serving as bases for over 140 artists.

Having seized centre stage, the leading advocates of modernisation through abstraction sought to reconcile the traditional and modern. Regrettably, their version of 'modern' was limited to an obsession with abstraction, while their 'traditional' merely picked up the lofty detachment from human reality expressed in ancient Chinese ink paintings. The most prominent example of this is the 'modern Chinese painting' which held sway for

a time. This superficial tacking together of today and yesteryear not only reached new lows of dogmatism on the theoretical side, but on the practical side it repeated the same mistake made by the scholar–artists who arrived in Taiwan a century earlier from China – that of cutting themselves off from the land in which they lived.

As competition between popularly formed art groups tapered in the late 1960s, local artists picked up on new western movements such as Pop, Op, hard-edge, conceptualism and land art in the attempt to carry the modern art movement forward. However, the negative impact of official suppression and political pressure exerted on cultural media supportive of modernisation and liberalisation cannot be discounted. Only when the movement to promote artistic modernisation by following new western trends abated was there space for the calm reflection greatly needed.

ANTAGONISM AND REFLECTION AMONG WESTERN DOMINANCE

In the 1970s the United States made the foreign policy decision to move closer to Peking, and Taiwan was forced to withdraw from the United Nations. Greater economic prosperity and a growing wealth gap aggravated the sense of crisis. Prompted to action, intellectuals spoke their minds, prompting another wave of reform. Scholars and devotees of culture were summoned to the island's agricultural and fishing villages to investigate the unseen reality of grass-roots society. An extensive 'Nativist' movement developed, which uncovered and expressed local realities while prosecuting a full-scale assault on blind acceptance of everything western.

From intellectuals to the general public, the expanded scope of the Nativist movement aroused interest in and concern for the immediate surroundings of Taiwan. Not

only were people able to assess the advantages and disadvantages of dependence on things western, but artists were drawn to take a new look at local life and social reality.

A number of artists directed their attention to rural and folk life in an effort to derive new inspiration from their native surroundings. Drawing on hyperrealism, they used images and photographs to achieve scientific precision and lifelike authenticity and capture the full essence of the countryside in a modern and popular style.

Meanwhile, in a series of four-year economic construction plans, industrialisation progressed at an extraordinary pace. The gross national product rose from US$430 million in the 1950s to US$5.45 billion by the 1970s, and per capita income jumped seven-fold. The soaring economy raised the standard of living and created a large middle class that was open to enriching its life through art. This atmosphere encouraged arts magazines and commercial galleries to present art rich in local cultural significance. The distance between Taiwan's artists and their public shortened, allowing local art to enter more homes and find expression in various public settings.

The two most celebrated artists identified with the Nativist movement are Hung Tung (1920–1987) and Ju Ming (b. 1938). Former folk artists without formal academy training, both have ridden crests of popularity for the primal simplicity of their work. But the greatest significance of the Nativist movement in an artistic sense was not the emergence of home-spun artists, but rather the landmark germination of widespread concern for the land under one's own feet which prompted mainstream figures in the arts movement to alter their approach and re-evaluate the modernist model against the immediate environment which nurtured their growth.

THE RISE OF AUTONOMOUS ARTISTIC CONSCIOUSNESS

The 1980s saw a new round of independent artistic activity. New arts organisations sprang up one after another, such as the League of Southern Taiwan Artists (1980), the Tao Tao Painting Association (1981), the Modern Chinese Painting Association (1982), the Modern Eye Painting Association (1982), the Taipei New Art League (1983), the 101 Modern Art Group (1982), the Third Wave Painting Association (1985), the Interactive Painting Association (1985), the Taipei Painting Group (1985), SOCA (1986), the Kaohsiung Modern Painting Association (1988), and Space II (1989). Painters residing abroad and art workers educated abroad returned to Taiwan in significant numbers, bringing with them the latest information and inspiring the younger generation of artists to look for new possibilities in their work. Government resources were committed to cultural development for the first time, allowing the establishment of municipal cultural centres and fine arts museums. The completion of the Taipei Fine Arts Museum in 1983, with its ample exhibition space, offered champions of the avant-garde and internationalisation a ready-made base to transplant their extensive new-wave exhibitions – the most notable being the massive biannual 'New Trend' exhibition. The subsequent emergence of private galleries brought a steady increase in the frequency of art exhibitions.

The surging popular forces released by the lifting of martial law in 1987 created a burst of activity on a scale unlike any witnessed before in Taiwan. This would prove the most noteworthy event of the decade.

The death of political strongmen and the dissolution of authoritarian rule helped loosen the existing political order and establish new social standards, allowing opposition forces buried under the oppressive weight of martial law to operate openly for the first time. Often people took their grievances to the streets, progressively unravelling the formerly tightly wound social order as they did so. The artistic realm exhibited even clearer symptoms of the post-martial-law order, displaying unprecedented sensitivity towards the political and social environments. With these changes the focus of concern of artistic work expanded from the countryside to the more immediate urban social realm as it condemned the existing political–economic structure and commercial society. The result was that young artists concerned with reflecting the challenges coming from the dramatic changes in their environment were given greater autonomy and more room for cultural reflection than before. These young artists willingly took themselves to the crossroads to come face-to-face with and experience rawer, more direct social reality, thrusting themselves into its very core in an attempt to derive inspiration from its potency.

Thus satirical work dominated by political and social themes captured the limelight. From photography, cartoons and small stage productions, to the stand-up comic art of 'cross-talk', television, film, poetry, and fiction, a counterculture grounded in satire was created. Abandoning contrived, enigmatic symbolism, young artists interpreted, criticised and gave voice to sophisticated issues of Taiwan society in a sharp, distinctly personal painting language. Examples include the exhibitions and events held by Space II, the Taipei Painting Group, and southern Taiwan's Kaohsiung Modern Painting Association.

Overall, the most favourable development to come out of the arts in the 1980s was the reconciliation of the contradictions between the 1960s and 1970s: dizzied passion for western trends resulted in whimsy and lack of

focus in the 1960s, while opposition to modernism in favour of a return to local grass roots in the 1970s fell into the trap of totemism. In contrast, the artists of the 1980s had regained their footing. Taking a more analytical approach to the understanding and absorption of new thinking, they also exhibited a deeper and broader approach to local themes. With these changes in consciousness, the latest international art trends could offer new means by which to break through political taboos, criticise society, and view the ailing environment. Hyperrealism and neo-expressionism, for example, exhibited new faces after internalisation and transformation by Taiwanese artists in the 1980s, while the incorporation of and experimentation with compound media and installation art allowed artistic creation to achieve a richer diversity.

ADOPTING A SENSE OF PLACE

In the 1990s the domestic transformation in Taiwan has taken clearer shape. The evolution of both the global climate and the local political scene tell us that the static authoritarian rule of the past is giving way to a new, more dynamic power structure. Applied to the artistic realm, the osmosis of progressive art throughout the world is no longer dominated by one overpowering wave at a time, but is broken down into a wide band of streams running perhaps along parallel lines. For Taiwan this means the matching of various creative energies against each other.

The pan-Chinese chauvinism generated under martial law has lost its grip over Taiwan. During the 1980s interest in the investigation of Taiwan history surged. Unofficial scholars and organisations devoted their energies to putting together a more comprehensive account of the island's saga. Scholarly interest in

Ju Ming
Taichi spin kick, *1991*
bronze, 185 x 190 x 155 cm.
Courtesy of
Hanart (Taipei) Gallery.

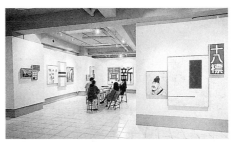

Space II.
Photograph: Lin Bor-liang
Courtesy of
Free China Review.

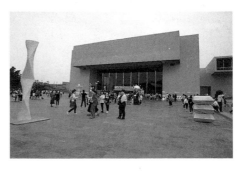

Taipei Fine Arts Museum.

53 ART TAIWAN

ART IN TAIWAN 1945—95

Taiwan's fine arts and crafts, which saw its initial rise in the late 1970s, has progressed to localised and specialised research. Especially in Taipei, Tainan and Kaohsiung, numerous individuals are quietly at work on historical field surveys and the collection of historical data, while private organisations are setting up an artists' data base and compiling a complete year-by-year chronicle of the development of art in Taiwan. The prevailing significance of these efforts is that they will systematically present the development of art in Taiwan in a clear historical context. The establishment of a comprehensive historical view will deliver the Taiwanese people's understanding from the haze of yesteryear, enabling them once again to understand how the various ethnic groups on the island, linked in common fate, emerged from a bitter past, and to recognise the innumerable challenges and prospects they must face in the future. Given people's yearnings for democracy and a participatory economy, intellectuals must take it upon themselves to initiate the foundation of autonomous historical and cultural dialectics so that Taiwanese can view the world with their feet firmly planted on their own soil.

TRANSLATED BY
David Toman; a different version of this essay, 'Setting the historical stage for the Taiwan Art Exhibition', appeared in *Taiwan Art (1945–1993)* (Taipei Fine Arts Museum, exhibition catalogue, Taipei,1993).

■ *Lin Hsing-yueh is a critic and artist. He teaches at the National Academy of Art and is the author of* Art in Taiwan: Forty Years' Vicissitudes (Independence Evening News Publication, *Taipei, 1987).*

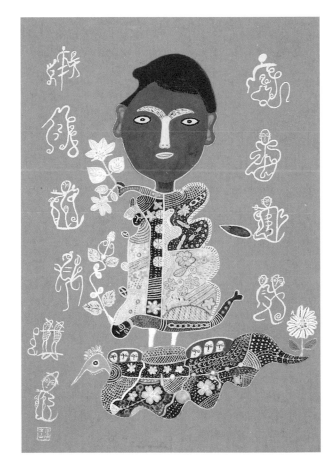

■ *Hung Tung,*
Untitled
postercolour on paper
63.9 x 44 cm.
Collection: Hanart TZ
Gallery, Hong Kong.

Local Consciousness and

by HUANG HAI-MING

As economic development and changes in the industrial structure have taken place, the gap between cities and non-urban regions has progressively grown in Taiwan. But at the same time we see the rapid and broad spread of artistic and cultural activities rooted in folk religion and local tradition. Yet we must distinguish the subtle and often elusive differences between folk activities currently in vogue and contemporary Taiwanese art coloured by folk culture. When contemporary art truly returns to tradition it should absorb and borrow, while also breaking away from conventionally understood identity to the establishment of new cultural identification. Progressive identity must undergo further upheaval, as it must first allow suppressed traditions and muffled social voices, the elements that constitute local consciousness, to be seen and heard. Many forces compete to claim and control the talisman of local consciousness. And as identity is not homogeneous, the process of building identification is bound to be filled with tension.

Such forces as the rise of local consciousness, the acceptance of the concept of popular sovereignty, and general scepticism towards national concerns, all contribute to the removal of taboos and the fruition of political liberalisation. Originally a pool of currents pulling against each another – China versus Taiwan, unification versus independence – the movement for political liberalisation has now gained the support of various predominant groups throughout society. Their critical input and protest has helped break up the existing monolithic social, economic and political structure, suddenly releasing a torrent of problems once hidden behind pleasing facades. Stirred awake, the Taiwanese people have begun taking a full and unprecedented interest in their right to existence and in everyday social issues. And while artists may not have played a vanguard role, they have been at least as affected as any group by the overall political and social climate.

The change in Taiwan's culture is directly reflected in popular religion, which is an integral component of local consciousness and a vital object of identification during times of crisis. In a cultural assessment in 1980, cultural anthropologist Li Yi-yuan noted the changes in popular ritual and activities, such as the electric organ-toting flower cars used in funeral processions. Borrowing eclectically from cultural forms, they are bereft of both modern and traditional values; all they offer is sensual gratification. At best, flower cars carry mourners and one or more women singing songs of mourning; at worst they become travelling strip shows. This nouveau riche attitude is also reflected in the architecture and ceremonies of Taiwan's temples; garish and overdone, lacking any sense of the sacred, worship of the gods becomes a means to display wealth. The excessive emphasis on popular religion in Taiwan following the lifting of martial law became a political totem wherein each political group acquired its own particular cultural label used to strengthen its position within the political realm. Less politicised was popular religion in relation to rapid social change. As the old structure fell apart and interpersonal relationships became more distant, a 'ritual of adjustment' took shape. According to Li Yi-yuan, 'The most important religious phenomena at this time are the ritual practices of local associations, and the spirit mediums'. These stress the preservation of the lines between various groups, the elimination of internal enemies, and inner purification. Given such conditions, we can see that alignment with local factions is quite natural. In addition, low-income, alienated Mainlanders, indigenous people, and all others who are unsure of their

Cultural Identity

societal role and who have migrated to the cities without any sense of place or identity, communicate directly with the gods via ceremony. Then there are 'revivalist' popular religious beliefs, which preach morality and principle and take traditional Chinese ethics such as filial piety and fidelity as their ideals. The movement, insofar as it can be called a movement, is a conservative, nostalgic, pacifying force in society. Exploration of Zen practice now in vogue throughout Taiwan can be included as part of this ritual of adjustment, despite its lofty philosophy and its metaphysics.

Popular religion is not limited to the countryside. It is prominent in older cities and towns, and in the big cities it can be seen in the religious rituals used as part of festivals or grand opening ceremonies for major public works. In the older cities and towns, when the statue of Matsu (the popular Goddess of the Sea) makes her annual rounds, entire towns come alive with excitement, demonstrating the powerful effect of popular religious ritual on ethnic identity.

The popularity and transformation of popular religious activities shows the relative strength of various forces, as well as society's desires and unrest. These quintessential Taiwanese activities are replete with totemistic or linguistic systems which lend themselves to direct representation in art. Also, Zen Buddhist culture has found an outlet in traditional eastern and contemporary western art. Recent Taiwan art borrows religious phenomena and symbolism, satisfying the needs of local consciousness and cultural identity on the one hand while exposing society's darkness and desires on the other. The juxtaposition of the sacred and the vulgar is used to challenge all would-be authorities and taboos.

Another important facet of Taiwan's local cultural style is the diverse amalgamation of architectural styles which

■ *Chen Shih-an*
Scenery at the ferry, 1959
fibrebase paper
40.6 x 50.8 cm.
Collection of
Taipei Fine Arts Museum.

■ *Buddhas in a Taiwan*
temple, Courtesy of
Taipei Economic and
Cultural Office.

LOCAL CONSCIOUSNESS AND CULTURAL IDENTITY CONTINUED

remains in the old towns situated at the periphery of the island's homogeneous, westernised modern cities: traditional architecture, temples, crude retro-classical structures, no-frills concrete block structures, and mixed architecture which blends local and western flavours. Small factories, dry-goods stores, multi-function homes, sparsely appointed markets, recreation and entertainment spaces, and open-air food stalls – structures of distinct stylistic diversity – exist together under a single skyline. Traces of agricultural village life, of various ruling regimes, and diverse cultural influences remain. Signs of all description, mixing Chinese, English, and traditional and modern styles, vie for attention before a backdrop of old, incoherent architecture. All kinds of vehicles are also swallowed up among the hodgepodge of architectural styles. This architectural complexion is constantly being razed, rebuilt and added to. Between imitation of the outside world and self-imitation, the cityscape has taken on a unique style of its own; perhaps this is Taiwan's most distinctive product.

Each urban centre contains a cosmopolitan, planned architectural style which constantly spirals outwards. While this style clearly departs from earlier tradition, it nonetheless retains a high degree of continuity with the amalgamated landscape already described. Taiwan now has the ability to compete on the international market, but it knows that in order to maintain its favourable position it must upgrade technology and industry. Taiwan's level of economic achievement and its global vision have made it unwilling to concentrate merely on attaining wealth at the expense of quality of life. Consequently, it has come to emphasise technologically advanced, rational, efficient, orderly, relaxed and comfortable production methods and ways of life. Looking about, it is obvious that the various western-

style entertainment and cultural facilities, consumer-culture facilities, large modern buildings, new community planning, and even government-sponsored public works projects, are largely constructed in typical modern western architectural style; where there is mixing, western post-modern style is more common than an East–West post-modern blend. As more and more Taiwanese venture abroad and compare living conditions in Taiwan and elsewhere, they are increasingly concerned with quality of life and are ambivalent about cultural continuity. On the one hand, those with the means to do so seem to seek to maintain an element of Chinese-Taiwanese cultural tradition, while on the other hand they hope to enjoy the material, and often the spiritual, comforts of first-class world citizens.

Taiwan's culture has always been realistic, flexible and diverse. It has the capacity to adjust to different ways of life and cultures, and to adopt foreign things as its own flesh and blood. Taiwan society is composed of a group of dauntless, hard-working people who also possess the ability to save themselves by the skin of their teeth in hard times. It is a jigsaw puzzle full of snags but which always seems to fit together. Always adding, always tearing down, always redoing and combining, this culture seems to want to progress towards western order and refinement, but it remains full of contradictions. While some people have come to respect the cultures of the various groups throughout society, and are ready to cultivate diversity, the culture itself is anxious to become a strong modern nation – at least one which finds itself on equal terms economically with the world's major nations. No matter how strong it may be, traditional culture is of little consequence in achieving this aim, as ultimately it is western culture which acts as the strongest integrating force. This is true in business as well as in the

urban landscape. For the younger generation, especially those raised with television in the cities, their sense of 'local consciousness' and 'cultural identity' is doubtless quite different from that of the same generation raised in the countryside. Having grown up in a constantly westernising world, what connection do they have to the land? And with what do they identify?

For decades following its retreat to Taiwan, the Nationalist government focused identity on Greater China, and only in recent years has this shifted somewhat to Taiwan. As might be expected, the cultural policy of the opposition Democratic Progressive Party places a significant emphasis on local tradition, but recent observations show that the newly dominant group in society (native Taiwanese) not only has no identity crisis, but is rapidly learning from advanced western culture and hopes to establish an ideal nation on its soil rather than emigrating abroad. Local consciousness and the goal of establishing a 'community of shared destiny' in a new nation are mixed together, while narrow 'local consciousness and cultural identity' are fading away.

Once these issues are grasped, we are more likely to have a rough sense of the shape of contemporary art in Taiwan, which carries a certain degree of local consciousness, and its possibilities. Otherwise we run the risk of just spinning our wheels. Many scholars have noted the 'nomadic' nature within the Taiwanese character. What is meant by this observation is rapacious development: consumption, the waste and discarding of resources after they are used, after which one moves on to plunder another location. The Taiwanese character knows no grand plans, but is focused strictly on small advantages close at hand and instant results. It fawns over the West in order to gain ready results, yet it is unwilling to learn from it properly. It loves face and

■ *Temple detail, Wanyinggong, Taipei district. Photograph: George Gittoes.*

■ *Restaurant, downtown Taichung. Photograph: George Gittoes.*

■ *National Chung Cheng University. Courtesy of Taipei Economic and Cultural Office.*

pretending all is fine (even when it is not), rather than dealing with problems. When problems get too big to handle, it runs away. Many modern movements advocate complete resolution in one step rather than following a prescribed order. However, such constant turning back to square one only wears away the foundations. Contemporary Chinese are either too absorbed and trapped in the past, or they view tradition with tremendous disdain and wish to discard it completely. Chinese people's understanding of the outside world is also often merely symbolic or generalised. In terms of artistic expression, realism per se does not exist. The outside world is often made out to be the embodiment of morality. We find that Chinese culture is long on achievement, but short on critical analysis. There is very little Chinese research on China's own collective subconscious, and neither are the culture's individuals very interested in their own subconscious world. This is not a meticulous society.

Having established such an understanding, we can explore the shape and possibilities of contemporary Taiwan art between the cracks of greater Chinese tradition (orthodoxy), local Taiwan tradition (orthodoxy), Taiwan's current status, and dominant global culture.

In the rush to break away from traditional Chinese culture it would be unwise to completely dismiss the vast resources contained within this heritage. Volumes of recently published writings speak to the richness of Chinese culture; unilateral acclaim or rejection for political reasons is also unwise. It is unnecessary to idealise Taiwan's past customs, just as it is useless to go out of one's way to reject its abnormal development. Instead, it would serve us best to carefully observe and understand the environment in which Taiwanese live, or find the 'deep cultural structure' which Taiwanese have established on the island. Lacking research on this level will make the Taiwanese insecurely reach for readily identifiable traditional totems. Furthermore, local consciousness and local culture are themselves like constantly changing organisms; overemphasis will serve little purpose except to foster dogmatism.

Here we find a paradox of sorts: the momentous changes that have transpired in Taiwan in recent years are unquestionably prompted by outside influences. The magnitude and speed of these changes have caught Taiwan unprepared to develop a vernacular adapted to the new environment. At the same time the country wishes to compete in the international market, so it must offer some exoticism while also conforming to western ideology (mainstream artistic discourse) on the one hand and maintaining a distinct regional flavour on the other. Perhaps it is not a paradox, but an indication of the need for close discrimination. We choose something, and desire to make something from what we have chosen, yet we also need to know how to measure or judge it. If our standard is the mainstream western system of interpretation, then our effort is of little use. This is why, when we focus on local art, we cannot be without local autonomy of interpretation.

Although we cannot remove ourselves from mainstream cultural systems of interpretation, we are equipped to tell how much subjective intent we have projected into our imitation, modification and misreading. Taiwan's art has lost its voice in the past, but now many pieces of a long-suppressed collective subconscious and blank history are again coming to the surface. In this, outside art often acts as a medium allowing floating imagery, imagination and memory to be collected together. In other words, our expanding language and conceptual framework will

eventually serve to help us form our own system of artistic thinking. 'Local consciousness' and 'cultural identity' are not limited to narrow meaning; rather, they are diverse, multi-dimensional, constantly evolving entities which must occasionally be held up to close scrutiny, or we run the risk of one day throwing refinement or the representations of any future identity of Taiwanese culture out of the window.

TRANSLATED BY
David Toman

■ *Huang Hai-ming, writer and critic, organised the exhibition 'Dis/Continuity: Religion, Shamanism, Nature', at the Taipei Fine Arts Museum, Taipei, in 1992.*

■ *Video games in Taipei. Photograph: George Gittoes.*

Notes on Taiwan's Cultural

by MA SEN

To the outside world the distant island of Formosa is as hard to grasp as an indistinct, secluded mountain in the clouds. Only in recent years has the island, whose proper name of Taiwan was long obscured, become the focus of international attention as one of Asia's 'Four Little Dragons', a model of economic development for the Third World and an eagerly watched liberalising prototype for the future of Mainland China. Economic growth brings wealth and benefits cultural promotion, and while not many trees may have been planted, those that have been are starting to bloom.

CINEMA

At the time the Nationalist government retreated to Taiwan in 1949, all the government brought with it from China from which to build a film industry was the lowly Agricultural Education Motion Picture Corporation. It grew to become the Kuomintang-operated Central Motion Picture Corporation. In its early years, with limited labour, capital and technology, and further held back by government policy, the Central Motion Picture Corporation produced no more than a handful of anti-communist and anti-Soviet propaganda films during the 1950s. However, as the economy took off and the public's appetite for entertainment increased, by the 1960s the number of films produced increased exponentially, reaching a pinnacle in the 1970s. Only seventeen films were produced in 1959, while this figure had skyrocketed to 119 a decade later in 1969. Between 1972 and 1974 a total of 609 motion pictures were produced, or an average of over 200 films each year. In 1978 a startling 292 films were made, putting Taiwan third in the world next to Japan and India, noted mass-producers. In terms of production per capita, Taiwan

would easily have taken top honours.

But quantity is never a guarantee of quality. The majority of films produced in Taiwan during the 1980s were kungfu films, 'swordsman' films and melodramas. Nevertheless, there was an occasional gem to be found, such as Li Hsing's *Qiu Jue* and Hu Jinquan's *Dragon Gate Inn*. Yet it was the new wave of film in the 1980s that first matched artistic aspirations with substantive achievement in the work of a younger generation of directors, including Hou Hsiao-hsien, Wan Jen, Chen Kun-hou, Edward Yang and Wang Tung. Many of these films, adapted for the screen from well-known novels or short stories, had the built-in sophistication and appeal of the original 'nativist' novels.

By the late 1980s Taiwan's film industry had begun working with its counterparts in Mainland China to produce some notable successes, including *Raise the Red Lantern* (1992, dir. Zhang Yimou), which was produced with Taiwanese capital using Mainland Chinese actors and crew. In 1993 Taiwan, Hong Kong and Mainland China cooperated on the production of *Farewell My Concubine* (dir. Chen Kaige), joint winner of the Palme d'Or at Cannes. In the 1990s independently produced cinema in Taiwan gained new maturity. Hou Hsiao-hsien's *City of Sadness* (1989), a moving reassessment of Taiwan's history, won the Golden Lion award at the Venice Film Festival, while Ang Li's stylish comedy, *The Wedding Banquet* (1993), shared the Golden Bear with a Mainland Chinese film at the Berlin Film Festival.

THEATRE

Theatre in Taiwan has travelled a far rougher road than cinema. In 1949, at the time of the Nationalists' return to Taiwan, the majority of playwrights, directors and actors in Mainland China were to some degree associated with

Development

the Communist Party. Apart from the army's entertainment corps, few theatre people made the move to Taiwan. The local populace, accustomed to speaking the local Taiwanese dialect, was alienated by the policy of designating Mandarin as the lingua franca of the theatre. Restrictive cultural policies, combined with a shortage of imported talent, meant that spoken drama in the 1950s and 1960s became little more than embellishment for festivals and national celebrations, with scripts heavily favouring anti-communist, anti-Soviet propaganda.

Different voices began to emerge in the late 1960s as playwrights – in Yao Yi-wei's *Jade Bodisattva* (1967) and my own *A Bowl of Cold Congee* (1967), for instance, – adapted Bertholt Brecht's epic theatre and the theatre of the absurd to Taiwan's circumstances. In the 1970s the influence of contemporary western drama was prominent, and Chang Hsiao-feng's religious-flavoured plays caused a sensation. Huang Mei-hsu, returning from study in the United States, created his own kind of theatre of the absurd. But the major breakthrough did not occur until 1980, when the first experimental theatre festival launched the small theatre movement. *New Lotus and Pearls*, written and directed by Chin Shih-chieh, not only won thunderous applause, but also created something of a craze. Several dozen small theatre troupes emerged in the early 1980s. After several decades of government efforts to promote the use of Mandarin, the language barrier was less of an issue and, with the relatively open political climate, a drama that reflected public opinion and engaged in social criticism was no longer taboo. People were involved in theatre, and several drama departments and training schools were established.

In the 1980s some small theatre troupes were committed to performing avant-garde work, notably the

■ *Poster for* The Wedding Banquet. *Courtesy: Palace Entertainment Corporation.*

■ *Still from* The Wedding Banquet. *Courtesy: Palace Entertainment Corporation.*

Wreckage Theatre and Left Bank Theatre, which adopted environmental and new formalist theatre styles. In contrast to their somewhat esoteric performances, other theatre troupes, such as the Screen Theatre Group, Phalata Theatre, and the Performance Workshop paid attention to audience reactions and the entertainment value of their programs for general audiences. Their creative process is workshop-based. The atmosphere at their shows – mostly comedies – has been electric.

DANCE

At first, folk dance and classical ballet in Taiwan were available for no more than physical exercise and as classes for interested individuals. In 1973, choreographer Lin Huai-min formed the Cloud Gate Dance Group. As the first Chinese professional modern dance troupe, Cloud Gate had no examples to follow. Lin Huai-min and his dancers created a new idiom. After two decades Cloud Gate has established itself not only in Taiwan but also internationally, in works such as *Winter Sustenance*, *Nirvana*, *Heritage* and *Dream of the Red Chamber* that combine western modern dance forms and Chinese inspiration. Encouraged by Cloud Gate's success, other modern dance groups have appeared in Taiwan. Cloud Gate's modern dance has also inspired the revival of traditional folk dance. Dance departments have been established at a number of universities for the cultivation of dance talent.

Dance and theatre, both ancient stage arts, have a great deal in common. In a broad sense the two disciplines are the most basic of the performing arts. When theatre and dance achieve a certain level of excellence, cinema, a relative latecomer, benefits by taking elements from both dance and drama.

Taiwan has more than twenty million people, and one million overseas visitors. Taiwan's average per capita income has topped US$10,000, and its foreign reserves usually rank among the world's top two. Yet even in the face of such impressive economic strength, Taiwan's cultural and artistic achievements need not take a back seat. In the forty-five years between 1949 and 1994, Taiwan's film, contemporary theatre and dance have clawed their way out of darkness to shine brightly in their own right. No longer can anyone claim that Taiwan is a 'cultural desert'. In addition to filling their stomachs with excellent Chinese cuisine, anyone in Taiwan can get their fill of cultural sustenance too.

TRANSLATED BY
David Toman

■ *Ma Sen is a writer, playwright, critic and professor of Chinese drama in the Department of Chinese Literature, National Cheng-kung University, Tainan.*

■ *Cloud Gate Dance Company. Courtesy of Taipei Economic and Cultural Office.*

■ *Peking Opera,* The White Snake. *Courtesy of Taipei Economic and Cultural Office.*

Taiwan: China's Other

by GEREMIE BARMÉ

Taiwan is a disturbing presence. While politically and economically an autonomous entity, culturally the Precious Island is caught in webs of belonging and becoming with Mainland China and Hong Kong. For the Mainland, in particular, Taiwan is the other China. It is China's Other.

Up to the late 1970s the mental geography of people on Taiwan and the Mainland had created a barrier along the Taiwan Straits that was as culturally impregnable as it was ideologically. For Taiwanese the Mainland was a land of evil, the masses living in 'deep water and scorching fire' *(shuishen huore)* under the rule of an insane government. The rich heritage of the past was therefore denied to them, while Taiwan had become the repository of all that was truly Chinese. For Mainlanders, Taiwan barely registered at all. It was, effectively, a 'terra incognita'.

During the 1980s that barrier gradually changed into a semi-permeable membrane and a process of culture, style, and notional osmosis has been under way ever since. The Taiwanese cultural solvent most often passes through and, in many cases, is modified by Hong Kong. The process is gradually drawing the two very different cultural concentrates into a state of equilibrium.

With contact came recognition, and from recognition followed prejudice and cliché. The most common Mainland response to any sign of Taiwanese confidence is: 'So you've got more money than we have, big deal!' *(Nimen Taiwanren bu jiushi you jige qian ma?)*. The Taiwan reaction is equally stereotypical: 'So what if you're bigger than we are?' *(Nimen bu jiushi juede ni da ma?)*. These remarks betray stereotypical elements of tension between Taiwan and the Mainland, but the relationship is now far more complex and layered.

The commercial culture of Taiwan – including advertising in both the electronic and print media – has a massive impact on Mainland China. Taiwan has filtered and digested the global culture of Euro-America and Japan for Chinese consumption and, like Hong Kong, has developed a form of product presentation and placement that appeals directly to Mainland consumers.

Yet the island provides much more than this. For the Mainland cultural world it is a source of off-shore funding and predigested cultural information, as well as being a site for exhibition and publication. It often provides an interested audience and, in some cases, a launching pad to the West.

Decades of militant communism and political infighting have forced nearly everyone on the Mainland into a pact with the Devil. Taiwan, despite its own melancholy past, has not been burdened with the direct weight of China's oppressively venerable history. As the beneficiary of decades of Americanisation, the island is seen as being both worldly wise but also more naive than the Mainland.

Its people are ignorant of the language, symbols, icons and fads of Chinese socialism. Although attempts have been made to absorb Mainland tropes, as in the case of the music of Lo Ta-yu (Luo Dayou) whose 1988 song 'Comrade Lover' *(Airen tongzhi)* contains lines like 'You're as beautiful as a slogan', Taiwanese nonetheless remain ideological innocents and Mainlanders deride them for it, although secretly jealous that they are forever deprived of the luxury of a relatively untroubled history. Unsullied by the horror and violence of Maoism, Taiwan points to a future of pure materialism, narrow social and national goals, and pragmatism. It is a prospect that both delights and unsettles people on the Mainland.

Music and film were the first areas in which Taiwan revealed itself to the Mainland.

From the early 1980s easy-listening love songs by such Taiwanese stars as Teresa Teng (Deng Lijun) found their

way to Mainland China. After decades of militant political anthems, these mellow tunes communicated a world that was both romantic and tacky, human and humdrum. It was just what sentiment-starved audiences on the Mainland craved. The authorities tried in vain to ban the music on the grounds that it corrupted public morals and was detrimental to the ideological health of the people. Cheap modern technology in the form of cassette players confounded the interdictions, and singers like Teresa Teng unwittingly launched a revolution in musical styles. Her songs also introduced a realm of bourgeois fantasy that helped pave the way for the boom in Mainland commercial tastes from the late 1980s. The success of Fei Hsiang, a Taiwanese singer of mixed parentage, is also noteworthy. Fei enjoyed meteoric fame on the Mainland in the late 1980s, the Eurasian teen idol's popularity with the young transgressing accepted Mainland Han views of mono-ethnicity.

The Taiwan folk–pop singer Hou Te-chien (Hou Dejian), one of the island's media stars, secretly defected to the Mainland in 1983. For the Taiwanese authorities it was an act of high treason; for Hou it was a journey of self-discovery. Hou's most famous song, 'Descendants of the Dragon' *(Longde Chuanren)*, is a brooding but patriotic folk anthem that had made him rich in Taiwan and soon gave him star status on the Mainland. It was the best-selling pop song ever marketed in China. Shortly after arriving, Hou appeared on Mainland Chinese television. Here was a famous singer who addressed his audiences without a script. His casual and familiar manner flew in the face of the strident, po-faced mode of Mainland performers. For his audience Hou was the embodiment of modern western music and yet possessed a 'westernised' personality that remained reassuringly Chinese. Official support for this returned 'Taiwan compatriot' gave Hou a

unique cultural freedom and he used it to promote a personal style that epitomised the impact of middle-of-the road Taiwan culture on the Mainland.

Hou was also the first to make music videos in China in 1988. He became involved in the 1989 protest movement and acted for a time as godfather to the nascent Mainland rock-and-roll scene. An outspoken and independent critic of the authorities, he was forcibly 'repatriated' to Taiwan in 1990.

Hou's old associates and friends in the Taiwan and Hong Kong music business turned their sights on the Mainland from the early 1990s, both for its potential as a market and as a source of export-quality talent. Soon, offshore companies had up-and-coming Mainland rockers under contract and were producing slick music videos to promote them.

It is a tried and true formula: a viable Mainland product is massaged with Taiwan–Hong Kong know-how and packaged for sale abroad. Success in the marketplace validates and reinforces the process. The relationship that such exchanges fosters is thus cultural, as well as being commercial and contractual. While Mainland dissident culture (be it intellectual or artistic) continues to annoy the Communist Party, Taiwan investors have helped it find a much-needed market niche.

From the late 1970s Taiwanese cinema gave Mainlanders access to a lowbrow aesthetic expressed in their own language and cultural idiom. Most of the films screened on the Mainland were mindless light comedies and asinine love stories that dwelt on the trials and tribulations of the island's westernised bourgeoisie. Yet, as in the case of the music of Teresa Teng, the world depicted in these films was strangely inspirational: it showed a receptive audience that a modern, self-centred and materialistic Chinese society was possible and, for

better or worse, what it might look like. It was just what me-generation Mainlanders wanted.

In the realm of art-house cinema, Taiwanese films had other lessons to teach. The 'new wave' of Mainland films surged in the late 1980s with filmmakers such as Chen Kaige, Zhang Yimou and Tian Zhuangzhuang achieving international fame. Around the same time, they discovered the work of Taiwan's Hou Hsiao-hsien.

The Mainlanders, regardless of their ostensible artistic agenda, were imbued with the rhetoric and vision of the Mao era and confident that they were the representatives of a new and independent voice in Chinese culture. They felt their work was epic both in nature and significance. Bloated with this sense of cultural afflatus, the Mainland directors were unsettled – and at times inspired – by the artistic vision of Hou whose interest in the commonplace, in ordinary people and the dross of daily life, and his concern with memory, and the past was something they had repeatedly overlooked. The films of artists like Hou Hsiao-hsien encouraged the Mainland directors occasionally to turn their gaze away from the grand sweep of history and attempt to give their work a more human dimension.

The same is true in the field of literature. Pulp love stories and martial arts fiction from Taiwan and Hong Kong are popular with the general reader, while highbrow fiction set on the Mainland before 1949 has inspired a range of Mainland writers (as well as film and television makers) to explore the realities of contemporary China at a temporal remove.

Taiwan is something of a 'missing link' for the Mainland. In many areas the significance of Taiwanese culture has been that it has built on and developed the values of the New Culture and May Fourth Movements of the 1920s. Forced to eschew the radical leftism and utopianism that grew up in 1930s China (and which

eventually won out on the Mainland), the 'Taiwan-style' is more personal and intimate, more at home with the grand tradition of China while still engaged with the problems of modernity and westernisation. The Taiwan-style allows space for the individual, as well as idiosyncrasy and irrelevance. While these things also concern Mainland cultural figures, they are rarely of cultural usefulness to them per se. Ultimately they are nugatory, barely more than minor distractions from major ideological debates and factional warfare.

But culture is not confined to these individuals, and perhaps the 'yuppie' style of Taiwan may lead the way for the small enclaves of cultivated wealth that are gradually appearing on the Mainland. There are the Ming-dynasty and Sino-Japanese-style tea shops, such as the Wisteria Teahouse (Tzu-t'eng-lu), and Pekinese eateries like Ching Chao-yin in Taipei which exudes an ambience and maintains a culinary quality that is still rare in North China. Books using handmade paper and traditional printing are produced and reach a sizeable audience of well-educated and avid readers. The classics of the West and culture of Europe and the United States can be appreciated with relative equanimity by the educated of Taiwan, many of whom have studied or travelled overseas. The 1990s has seen the first efforts of Taiwanese entrepreneurs to export (or is it re-port?) this elite ambience to the Mainland.

While Taiwan has prized itself for being a stronghold, enclave and even a fortress of Chinese culture, maintaining and developing a tradition lost to the Mainland for political reasons, it has also undergone a form of cultural ossification and kitsch-conversion that have made it possible for Taiwanese artists and writers to play increasingly in a field of juxtaposition and irony in a manner not so readily available to their fellows on the

Mainland. The latter still live within a more stark ideological sphere and their playfulness has tended to concentrate on subverting a body of political symbols rather than on attempting to examine the nature of subversion itself. Since so few on the Mainland are at home with the legacy of anything other than the Maoist past this is hardly surprising.

While Hong Kong is a fundamental model and its influence pervasive in the south of China, particularly in the neighbouring Cantonese-speaking province of Guangdong, the Taiwan-style has a more diverse impact. Of course there is the larger Fujian or *minnan*-dialect region of Taiwan and Fujian Province and the general impact of Taiwanese capital along the coast, but it is the Taiwanese power as a Mandarin-speaking, central cultural entity that gives it the greater prestige.

Taiwan encountered and became absorbed into the network of cultural globalisation before the Mainland did. As such, Taiwan-Chinese (*guoyu*, 'the national language', as it is called in Taiwan, or *putonghua*, 'the standard language', on the Mainland) has developed a modern, fashionable and even post-modern vocabulary. It is a language that moves freely through the osmotic shield of the Taiwan Straits, at times enhancing, and then obstructing, exchange.

■ *Geremie Barmé is a Fellow in the Division of Pacific and Asian History, Research School of Pacific and Asian Studies, Australian National University, Canberra. He has written widely on Chinese cultural and intellectual history and is the editor of* East Asian History. *His publications include two volumes of essays in Chinese, and his most recent book, edited with Linda Jaivin is* New Ghosts, Old Dreams: Chinese Rebel Voices. *(Times Books, New York, 1992).*

■ *Still from* The Time to Live and the Time to Die. *Courtesy of Ronin Films.*

■ *Still from* City of Sadness. *Courtesy of Ronin Films.*

New Art, New Tribes

by VICTORIA LU RONG-CHI

In the 1980s, a decade of confrontation and change, the people of Taiwan reclaimed their own interests as they stripped the last layers of illusion off the worn political slogans of yesteryear. Martial law was lifted in 1987, and Lee Teng-hui replaced departed strongman Chiang Ching-kuo (son of Chiang Kai-shek) as the Kuomintang's front man in 1988. As the ruling party struggled to retain its authoritarian grip, an organised opposition party gathered momentum with each election, paving the way for new forces at the top and establishing a new political climate.

If the late 1980s were the post-Chiang Ching-kuo era, then a changed Taiwan in the 1990s can be considered the Lee Teng-hui decade. Repression of dissent in the name of chimerical doctrine (the Three Principles of the People) has given way to an agenda which places local concerns first. Three premiers have come and gone during Lee's reign, and the period since 1987 has seen the political order uprooted, social mores unravelled, and economic development frustrated. With each dramatic change, the media's directionless reporting has barraged the senses, subverting meaning and sharpening contradiction. The struggle to identify with symbols and the ideological contention of the 1980s became a game of codification in the 1990s. Ideology became the foundation of social identity, and mass movements were readily used to display strength in political struggles. Emerging from an age of monism and dualism, and now enmeshed in the frenzy of numerous would-be heroes contending for the upper hand, each ethnic group placed its bets on its own legitimacy in order to gain full control. Political passions boiled while the stock market cooled off, and established values broke and crumpled before a new collective consciousness could take hold. Given their disembodied sense of place among such social unrest, it makes sense that artists could not possibly be representative of any particular style in conformity.

For 'post-1989' Mainland China, the 3–4 June 1989 Tiananmen massacre has its historical significance as a point of demarcation, as seen in the art shown in 'Mao Goes Pop' at the Museum of Contemporary Art, Sydney, and elsewhere in 1992. The situation is different for contemporary Taiwanese art.

The slump that afflicted the Taiwan stock market in the early 1990s actually stimulated investors to turn their attention towards art. Speculators armed with vast sums of cash assaulted the art market, overnight creating millionaire artists and stirring a sleeping international art market to action in just two years' time. Yet, just as activity reached its peak, the market dropped back into its slumber.

Can contemporary art, long pushed to the margins of the cultural realm, and coming out of a decade of dramatic change – a decade which saw its star rise among economic prosperity – develop into a cultural resource for the times?

Distinguished from each other by choice of style and use of technique, the group of artists who began, in the late 1980s, to reflect on and explore the intrinsic nature of Taiwan through symbols and signs was united in the sense that each artist possessed common ideals and callings rooted in a strong identity with the Taiwan experience. This differentiates them from Lai Jun-jun, Tsong Pu, Chang Yung-tsun and Chen Hsin-wan, who were ambassadors of sorts for modern Taiwan art in the early 1980s. The interpretation of symbols and decodification of the symbolic meaning of designs in the work of Yang Mao-lin, Wu Tien-chang and others is largely connected to narrative, as their symbols and patterns are essentially linguistic in nature. They often use metaphor and analogy to communicate their messages. Wu Mali and Lien Teh-cheng also make ample

use of symbols and metaphorical designs in their work, but they are further distinguished by strong critical and ironic qualities. The social nature of their work is immediate and strongly suggestive of current issues. The impact of the movement to 'paint Taiwan if you love Taiwan' went deeper than the selection of subject matter to touch on artistic approach. From exploration and pursuit of the so-called international nature of the West, the inward turn towards reflection on individual place and autonomy affected the overall approach to art.

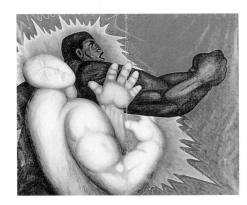

The emergence of Hung Tung in the 1970s – his naive style suffused with folk colour and endlessly varied, peculiar patterns – had a tremendous impact on artists of the 1980s for the complete expression of the imagination of popular culture in painting. Kuo Jen-chang turned the carved inscriptions of Han-dynasty tablets into dark lines describing the forms of classical figures, successfully taking the fast-paced media images of contemporary life to put a modern spin on classic mythology. Lee Ming-tse's paintings are like allegorical folk tales, populated at once by magical illusion and the normalcy of life.

The social critics (evaluators) have turned to satirical, humorous, reflective and exaggerated approaches to draw attention to the myriad distortions, contradictions and hang-ups that exist between society and individuals, and between national status and the people. Hou Chun-ming's series of prints is his personal interpretation of sex. Produced as books were in former times by using paper print, they achieve the look of ancient Chinese morality classics. But appearances can be deceptive, and Hou is dead set against being subjected to any kind of conventions or restrictions. Using his uniquely personal language, the artist exhibits the struggle and torment of his inner psyche. The deceptive expressions that run through Hou's work are the same as those used in the word games in vogue with

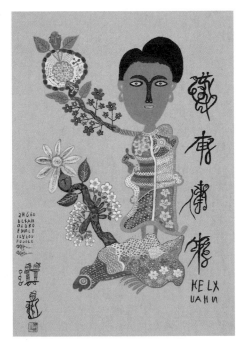

the Taiwan media. Here, they are deliberately clouded to stir up the myriad connotations of understanding inherent in the conveyance of language, luring readers into a maze of value judgments.

Like parables, Huang Chin-ho's collages of Taiwanese town culture leave viewers room to exercise their imaginations. While his technique owes considerable debt to the neo-figurative movement, he uses vibrant, exaggerated colour schemes and the use of contrast typically found in Taiwanese folk art to create the festive air of Taiwanese villages decked out to attract good fortune. Bursting with flamboyant figures from open-air theatre, the comic postures of the medium commuting with spirits, and the unexpectedly candid expressions of villagers, his work evokes strong emotion. At the same time, his criticism – a satirical, mocking mix of raucous laughter and praise – can be seen within the style of Taiwanese nativist expressionism.

Lien Teh-cheng employs the language and images of the mass media itself to make it the object of his dissection, critique, subversion and reproduction. Lien's critique, founded in rational analysis free of personal emotion, usurps the authority and exposes the inflated exaggeration of the media's linguistic and visual imagery. In so doing, he restores words and images to simple symbols, colours and forms. Lien Teh-cheng's gigantic written symbols and billboard images carry the essence of American Pop art, using instantly recognisable symbols to communicate on a mass level.

Mei Dean-e stands out as a pioneer among his contemporaries in the new generation of Taiwanese artists for his understanding and realisation of Dadaist art. What separates Mei from conventional Dadaism, though, is his exhaustive perfectionism. By breathing new life into old objects, he puts aesthetics back into his work in a dramatic departure from the anti-aestheticism of

Dadaism. As a result, Mei Dean-e's works possess the engaging humour and nihilistic rebellion of Dada at the same time as they accommodate the pursuit of finery and grace essential to classical art. Up against Mei Dean-e's exhaustive scrutiny and criticism, political and social themes are frozen into tributes and memorials, or even raised to the level of historical allegories completely devoid of revolutionary force.

Another group of artists is detached, refraining from expressing its personal opinions and taking a subjective view. These artists merely take what they see and record it in imagery. So, as transportation projects have touched the lives of every resident of Taiwan , drastically changing the face of the urban landscape, artist Lu Hsien-ming makes an elevated highway from the Six-Year National Development Plan his subject to complete his disinterested, inorganic series of city portraits. Masculine lines run across the image like the cold grey components that sit at the city's base. Here, human space has been cut away, compartmentalised, then put back together again.

The number of locals travelling to and returning from the West has increased dramatically in the 1990s. This group of people, who have encountered the neo-figurative movement, witnessed the revival of Arte Povera and experienced the return of neo-conceptualism in Europe and North America is largely concerned with the execution and realisation of ideas, from selection of materials, to application, to completion, even to their willingness to make materials on their own, to use ready-made objects, or to have them custom-made. Ku Shih-yung (returned from France) and Chu Chia-hua (returned from Italy) are concerned that everything should be put into the service of conceptualisation. As Ku's conceptual presentation relies heavily on the symbolic import of appearances, his works exhibit a poetic, meditative

articulation. Chu Chia-hua received a baptism in western Pop art, hence he has no qualms about using common ready-made objects in his work. As his work emphasises the composition of concept itself, any article that he has handled is bestowed with new life, in the fashion of Italian master Piero Manzoni, breaking down artistic creation into conception or the artist's will. For this generation of new artists, born since the 1960s, the Pop art of the 1960s and the conceptual art movement of the 1970s is a touchstone of growth far removed from powerful western painting traditions. While many of them experienced the West's figurative revival, they still believe in the primacy of conception, putting them in agreement with the neo-conceptualist movement in the West.

Another feature of the generation of artists born since the 1960s is their partiality towards theoretical experimentation. Unlike the first generation of post-war artists, the new generation is sceptical and unlikely to follow anything blindly. They are the kind of people that must see the results of experiments before they become believers. These new generation artists use the process of experimentation to heighten their understanding and subsequent varied expression.

Rapid economic growth since 1970 in Taiwan has created a breed of Taipei urbanites dedicated to the pursuit of sophisticated gratification. Whether in lifestyles, behaviour or mode of thinking, this new species bears the stamp of the changing times. And while this influence has given them the ability to grasp the instant information of the electronic age and to think on their feet, they have never lost the ability to fashion their own images and personal styles. Cheng Tsai-tung represents Taipei's breed of creatures in realistic fashion. Fan Chiang Ming-tao's gilded pottery, dazzlingly rich and bright, is a brilliant portrait, the artist reminding people of the gold flakes

■ *Mass rapid transit system, Taipei. Courtesy of Taipei Economic and Cultural Office.*

■ *Taipei Fine Arts Museum..*

sprinkled on steak and gold leaf floating in soup, and of the women adorned from head to toe in gold ornaments, all representing Taipei's gilded culture.

Yu Peng's ink and brush painting has always shown a playful mockery of life. His brushwork is free and unrestrained and his style strong enough to typify the leisurely thoughts of this generation of youth. The urbanites are inextricably linked to the soaring Taiwan economy and the formation of a material culture. This new monied gentry pursues quality spiritual activities. What comes through in their art goes far beyond the base tastes of Pop art; what really attracts them is a multicultural sensibility belonging to no particular time or place yet which pays tribute to them all.

Since primitive times, humans have never ceased to engage in ceremony; only the objects of worship change from generation to generation. The art world's shamans present art within the context of ceremony, breaking down meaning and building it back again through ceremony to show how art can elevate the spirit. Huang Chih-yang's paintings are like banners at the Taoist altar, each with the deep power to deliver souls. So powerful are they that they let viewers participate in the ceremony and complete the religious exercise with their imaginations.

Never in the several millennia of Chinese history have the great contributions of women been heralded. In every realm, concentration on the enterprises of men created a feudal patriarchal order. In the past, women's names were absent from family trees; only the names of their fathers and husbands were listed. Pursuit of equal rights between the sexes was the subject of a movement in the late Ching dynasty and early Republican years, and the modernist movement centred around Mainland Chinese intellectual youths also advanced the ideal of equal rights. Long under the dual oppression of patriarchal

subjugation and Japanese chauvinism, it took until the 1980s for a feminist movement to appear in Taiwan, encouraged by the forceful feminist movement of the West in the 1970s and led by the new women who had returned from residence abroad.

Yan Ming-huy, who returned to Taiwan in the 1980s, is an artist with an explicit feminist consciousness dedicated to promoting feminism. The various associations with sex attached to fruits by Yan Ming-huy are just some of her mechanisms of expression. Wu Mali and Chen Hui-chiao are adept at purifying the baseness of material wares to remove the symbolic meaning of objects and bestow on them sacred artistic connotations. The narrative or symbolic tendency of female artists often leads to intuitive, yet biographical, diary-like observation of the events around them and to the recording of feelings, as in the work of younger artists Chen Hui-chiao and Chiu Tse-yan. The sundry details of family life provide a point of departure in the work of many women. Hou Yi-ren's feminist consciousness is rooted in the cycles of nature and the nurturing capacities of the mother's body. Hou is concerned with the outward expression of inner reflection, and she has gone to great lengths to explore the lives and status of women.

Art reflects the times and the environment. The 1990s have so far seen increasingly bizarre art in a stylistic sense, and a hesitant overall sense of human development as humanity wavers back and forth on the brink of change, unable to decide where to turn.

In the early 1990s, together with the diversification of political views and fracture of social mores, culture displayed unprecedented diversity in Taiwan. Art promotion, formerly the exclusive territory of officialdom, was opened to participation from all sectors of society to become a diversified order. Together with the dramatic

appearance of commercial galleries in the early 1990s, 'alternative spaces' organised and/or supported by artists became prime movers in artistic promotion. On top of their art, the artists themselves have entered the realm of management and it is also common now for artists to dabble in criticism. Corporate sponsorship of culture is acceptable, and administrative personnel in cultural enterprises are no longer public servants in lesser government departments; instead, people assembled from all fields are working in the area. The authoritarian era has given way to diverse overlapping systems which, while separate, are allied. This is not just true of economic and political strategy; in culture, too, it is the trend of the times.

A veteran of centuries of metamorphosis, can Taiwan make the idea of its people's 'common destiny' more than just a linguistic game? The Taiwan art world is now emerging from prolonged silence. Today, as many of the world's nations come to terms with multiculturalism, we should appreciate the value of multicultural co-existence and avoid creating cultural monoliths. Artistic creation cannot be isolated from the times and the social environment. Individual geniuses aside, artistic accomplishment is the product of interaction in the greater environment. Miracles can occur in economic growth, but cultural growth is a laborious process.

TRANSLATED BY
David Toman; material in this essay appeared in a different form in the catalogues, *New Art, New Tribes: Taiwan Art in the Nineties* (Hanart (Taipei) Gallery, 1993) and *Taiwan Art: 1945–1993* (Taipei Fine Arts Museum, 1993).

■ *Victoria Lu Rong-chi is a Taiwan art critic and writer. She curated the exhibition 'New Art, New Tribes'.*

■ *Teng Nan-kuang*
Taipei, *1950*
fibrebase paper
40.6 x 50.8 cm.
Collection of
Taipei Fine Arts Museum.

Real Fictions

by DEBORAH HART

The concept of 'real fictions' in the context of contemporary art in Taiwan implies imaginative reconstruction of internal and external realities – of past and present, public and private concerns. The spirit of radical re-invention is pertinent to an artistic environment that over the past decade has been in a state of flux: engaging with social and political changes, investigating past histories, wrestling with local versus international perspectives, merging strands of tradition and innovation and insisting on freedoms of personal expression. While monolithic certainties are an anathema, within the plethora of concerns and stylistic diversity it is the undercurrents of imaginative transformation and the interplay of fact and fiction that give much of the art in Taiwan in the 1990s its verve and potency.

Symbolic representations, poetic transmutations, heightened realities, surreal creations and dream worlds need to be considered, not as imposed notions of the search for 'exoticism' or 'otherness', but as integral to particular contexts and specific artistic explorations in a country where the pace of life, of change and of vigorous debates continually shape and re-shape the ways in which artists relate to their environment. On a personal level, insights into these specificities emerged during successive visits to Taiwan.[1] It was through the exchange of ideas and information – through looking at art, through exhibition documentation, through discussions with artists, museum staff, writers and critics, through visiting artist-run-spaces, museums, galleries and artists' studios – that a process of deepening understanding gradually evolved.

Taiwan's population of some 20 million is somewhat larger than Australia's. First, disparate impressions reveal a place that is dynamic and complex: voluminous traffic and thousands of mopeds (sometimes accommodating whole families), beautiful Taiwan brides in pristine white wedding dresses having their photographs taken with their new spouses, monuments of prestige and power, vast squares, huge department stores, little street stalls on pavements and in narrow avenues, night markets, old and new Chinese temples, Japanese-inspired tea houses, KTV entertainment venues, McDonalds, rampant construction of buildings, roads and bridges, mine sites on the side of ten-lane highways.

The question of how real or fictitious these impressions are in relation to local perceptions takes time to unravel. In meetings with artists in Taipei, Taichung, Tainan and Kaohsiung, dynamics and tensions within the art world in Taiwan became apparent. One of the most fervent debates throughout Taiwan's art scene over the past decade has been the tension between so-called 'international' trends and a passionate concern to express a local, grassroots consciousness. These seemingly contradictory impulses have been exacerbated by events in Taiwan's history through the 1980s, on the one hand, and by the fact that many artists have chosen to study art in Europe and the United States on the other. While artists from the south are discussed elsewhere in this publication, it should also be noted that southern Taiwanese artists have consciously developed their own art practices rather than following the latest stylistic innovations in the Taipei art scene.

Since the lifting of martial law in 1987 suppressed voices of indigenous and diverse ethnic groups in the community are gradually beginning to be heard. The critic Lu Chin-Fu has noted that 'political liberation has had a direct effect on the development of art. The appearance of new opposition parties in 1986 and the lifting of martial law in 1987 are events with great

historical implications. The messages conveyed by these events are beginning to be reflected in the arts'.[2]

The desire for specifically local, social and historical content was already evident in the early 1980s with the formation of the 101 Modern Art Group by Yang Mao-lin and Wu Tien-chang, who noted that the group 'welcomed the emphasis on the use of symbol, metaphor, paradox and irony'. Critical investigations of past and present by artists have made a dramatic impact – in Wu's challenging perspectives on authority and military repression in 'Portraits of the Emperors' series (pls. 2); in Yang's reconstruction of images from colonial history in the 'Zeelandia' paintings from his 'Made in Taiwan' series (pl. 1), and in different ways in Taichung-based artist Huang Chin-ho's bold, brassy, satirical commentaries on contemporary society and specific localities, that so successfully merge current realities with fantastic innovations.

A recurrent feature of the contemporary art scene through the 1980s and into the 1990s is the way in which artists of like sensibility often group together. This is evident in the artist-run-spaces such as IT Park (founded by Chen Hui-chiao, Tsong Pu and Liu Ching-tang) and Space II (founded by sixteen artists). In both instances these spaces were established in the late 1980s as forums for artists to exchange ideas and exhibit their works, including installations that might be difficult to show in an institutional context or be considered 'unsaleable', in an environment that facilitated total freedom of expression. As Fan Chiang Ming-tao, one of the founding members of Space II put it, 'I can make something that people will buy ... but I also have some experimental ideas that can only be realized in Space II'.

In a number of inventive installation works there is a satirical play on Taiwan as a 'gilded culture'. Gold is

■ *Restaurant, downtown Taichung. Photograph: George Gittoes.*

■ *IT Park, Taipei. Photograph: Lin Bor-liang. Courtesy of* Free China Review.

beautiful and seductive but with the potential to corrupt. Wu Mali makes a bold statement, with her *Prosperity car* (pl. 5), comprised of shiny, gold geometric boxes on wheels, with a bright red bow on the front. This slick machine is like an ironic, fantastic and humorous gift; a commentary on the veneration of wealth and material culture. Similarly, Fan Chiang Ming-tao's installation of golden tiles with lush green grass – like a treasured fragment – pushing out from the centre, questions the price of the 'economic miracle' and the idea of paradise found or lost. Here *Dignity of green* (pl. 4) is a poignant title implying the desire for retrieval and balance, for taking into account the energy forces of nature.

When Margaret Shiu Tan arrived in Taipei in 1976 from Hong Kong she was deeply impressed by 'the immensity of traditional oriental arts' but found that life in 'the developing city proved too chaotic to withstand as Taiwan moved from a tradition bound society to that of an economic dynamo of the region'. Her way of coping with the confusion on a personal level was to establish a link with the past through absorbing the essential principles of Ikebana and, most significantly, through her work in ceramics, which has developed over the years into her current art practice. In her *Clouds* installation at IT Park, white, wafer-thin shards float and drift within the confines of their black boxes, creating an impression that is simultaneously dramatic and delicate. Nature provides balm to the spirit in a world of cacophonies. Noise and silence. Subtle resonances shine through in the work of Tsong Pu and Chen Hui-chiao; in Chen's *Silent picture* (pl. 21) the precision of needles and fine criss-crossing threads dissolve external realities into internal and spiritual realms of experience.

Personal enquiries, the life of the spirit, retreats into nature, fantasy and reality weave strong undercurrents and find vastly different means of expression in contemporary Taiwanese art. In the distinctive intimacy of Cheng Tsai-tung's and Yu Peng's paintings there is a sense of poetic integration of friends and family members in tranquil gardens and interiors. In Cheng's works internal, meditative states are heightened by the sense of space, whereas Yu's ink paintings are densely inhabited by fragments of past and present, in a whimsical rendition of the Chinese literati style. In Yu's extraordinary work *Mystic aura from the chasms* the sense of playful irreverence – of contemporary figures inhabiting a reconstructed world of traditional sensibilities – is combined with deeper psychological resonances, the contemplative mood being challenged by the presence of a wild, fantastic creature and the caged head of a man.

The highly diverse transmutations of tradition with contemporary expression, cross-referencing past and present, is evident in the bold, energetic whiplashes of calligraphic black on white in the paintings of Chen Hsin-wan; in Kuo Jen-chang's radical fusion of elements of traditional folk art with fragments of Pop art and in the overtly sexual, satirical woodblock prints of Hou Chun-ming.

Symbolic, sensual imagery informs Yan Ming-huy's paintings, which are indicative of an artist taking control of her own representation. In the vibrant colours and accentuated illumination of fruit and vegetables, flowers and textured fabrics, she weaves patterns of gradual revelation and exposure. At times they are decorative, as in a painting of a mass of red chillies interwoven in the centre with ribbons, while in other instances the erotic implications are explicit. Voluptuous curves of plums and apples and melons – seen from a distance or in microscopic close-ups – suggest fertility and seduction.

At times surreal currents emerge, as in Huang Chih-yang's art. When installed, his scrolls have a tactility and floating quality; a distinctive oriental sensibility. However, the most striking and idiosyncratic aspects of the work resides in the sheer imaginative power of the imagery. Here human forms are transmuted into hybrids of insects, plants and animals – spiny, thorny, cactus-like, billowing creatures that bristle with energy. Réné Crevel, in *L'Esprit contre la Raison*, noted: 'The poet does not put the wild animals to sleep in order to play the tamer, but, the cages wide open, the keys thrown to the winds, he journeys forth, a traveller who thinks not of himself, but of the voyage, of dream-beaches, forests of hands, soul-endowed animals, all undeniable surreality.'[3]

To enter into a room full of Chiu Tse-yan's charcoal drawings in an exhibition 'Animals and their Souls' at Taiwan Gallery was a very moving experience. From the hustle and bustle of downtown Taipei one was transported into a mysterious and eerily solitary realm. The haunting mood was evoked through the implied silence in these dreamscapes, inhabited by strange creatures and illuminated by the dramatic concentration of pools of bright light against velvety blackness. Even in quite small drawings there was often the sense of vastness, of vertiginous cliffs or 'carved' out edges of land plunging into deep space. While the essential stillness is retained in drawings such as *Dreamland of night walk* 1993 (pl. 28), the compressed energy is also partially released through the perilous leap of an animal in mid-air over a massive, gaping void.

Fantasy and dream recur in Lien Chien-hsing's paintings. Lien was one of the members of the Taipei Art Group. A native of the northern fishing port of Keelung, he often returns home for inspiration. 'Memories of my

■ *Artist Fan Chiang Ming-tao (Marvin Fang). Photograph: Lin Bor-liang. Courtesy of* Free China Review.

■ *Artist Margaret Shiu Tan in her studio. Courtesy of the artist.*

childhood in Keelung, and my home surrounded by mining sites, have provided me new subjects to express feelings of both pleasure and pain in an alienating, industrial world.'[4] *The lioness in deep thought* (pl. 29) is a work of potent theatricality. The architectural structures, like stage props, form a semi-circle around a De Chirico-like empty space. On a springboard along the perimeter is the image of the lioness – perched, waiting – creating a sense of psychological tension and ambiguity. Delicate traces of rain appear in the background and water forms a small pool from which tentacles tentatively work their way through the brickwork. Nature is contained, entrapped, waiting to break free.

Despite highly polarised viewpoints and stylistic diversity in contemporary Taiwanese art in the 1990s, overlapping strands of intent are ever present. Particular individuals and groupings undoubtedly hone out their specific place and metier in the constellation of competing voices. Nevertheless, careful contemplation of the works reveals the precariousness of seemingly rigid boundaries. Investigations of social and political issues cross media specificities; the interplay of past and present flows within contradictory stylistic devices; the solace of the natural world repeatedly provides the respite of dream in a densely populated and rapidly evolving place. Symbolic or abstracted interpretations, fantastic inventions and current actualities co-exist, for ultimately it is through the power of the imagination – whether through accretions or distillations – that these artists reveal their capacities to transform internal and external realities, and enliven our perceptions of the worlds in which they live.

■ *Deborah Hart is a curator and writer who lives in Sydney. On behalf of the University of Wollongong she curated 'Identities: Art from Australia', the first major exhibition of contemporary Australian art to be shown in Taiwan. She is curatorial adviser at the Museum of Contemporary Art, Sydney, for the exhibition of contemporary art from Taiwan.*

NOTES

1 This occurred when I was working for the University of Wollongong as curator of 'Identities : Art from Australia', shown at the Taipei Fine Arts Museum in 1993–94.

2 Catalogue essay for the exhibition 'Message from Taipei', organised by the Hara Museum of Contemporary Art, Tokyo and the Taipei Fine Arts Museum. In relation to the rights of indigenous peoples, their voices have only recently begun to be heard publicly, as was evident in the street demonstrations in Taipei in December 1993.

3 Quote by André Breton in *Le Surrealisme et la Peinture*, 1928, cited in Herschel B. Chipp, *Theories of Modern Art*, (University of California Press, Berkeley, 1968), p. 414.

4 Free China Review, vol. 43, No. 3, March 1993.

■ *Artist Yu Peng.*
Photograph: George Gittoes.

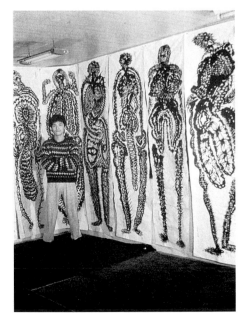

■ *Artist Huang Chih-yang.*
Courtesy of Space II, Taipei.

Touch, Texture and Concept:

by JOHN CLARK

The presence of a specific culture and way of life in Taiwan is both ever-concrete and barely eluctable. An outline of this problem will contextualise the three modern women artists to be discussed here: Chen Hsin-wan, Lai Jun-jun, and Wu Mali.

In Taiwan, and not just in the capital, Taipei, no one can miss the massive industrial and urban development, the hordes of high-school and university students, the shopping malls, government offices and, in the last ten years, cultural centres. But where are we to find codified a set of cultural values and their representation, or even their hostile anti-representation? It is easy to look for these in the domination of the written language and of Mandarin or National Language *(guoyu)*, or the prevalence of neo-traditional Chinese painting *(guohua)* and its pair, oil-painting *(youhua)*. The predictable clash between the relics of the Japanese colonial period and the post-1949 transfer of Mainlanders is now hardly manifest. At the level of language, differences in value are effaced by the relegation of the Taiwanese language to *minnanyu*, a kind of regional dialect not worthy of national expression except for occasional television voice-overs. Unsurprisingly perhaps, the deeper cultural expression of Taiwan is found in those places where it is not easily deflected by higher systems of domination: in everyday verbal exchange, in family structure, in religious ritual and social etiquette, and in certain notions of place. With the 1970s de-recognition by the United States and the emergence of a notion of homeland *(xiangtu)* the specificity of Taiwan has also been represented in a type of genre painting. In the 1980s a Taiwanese feel was also seen among formalist resistance to approved art conventions in minimalist work, installations, and in a new expressionism.

Women in Taiwanese families can occupy important economic control roles, but despite the existence of women academics, particularly from Mainlander families, and even of Taiwanese women ministers, the commanding heights of cultural value and expression are dominated by males. All the famous post-1949 painters of *guohua* were male, and so were most of those of *youhua*. Those active in the innovatory Eastern *(Dongfang)* and Fifth Moon *(Wuyue)* groups in the late 1950s to mid-1960s included only one or two women, and none in a leadership role. Even in recent years, all thirty prizes shown as having been awarded annually to creative newcomer artists by the *Hsiung Shih Art Monthly* between 1976 and 1990 went to male artists, for which period women appear to have served on the selection committee only three times. Why then was there an emergence of three significant women artists in the 1980s?

Possibly their prominence indicates the surfacing of a deeper-seated trajectory: the route out of encapsulation in traditional family-oriented roles via education or economic surplus. Actually the first example of a major woman painter had access to both. She was Chen Chin (b. 1907), who came from a wealthy family and in colonial, pre-war Taiwan was educated in Japan in neo-traditionalist Japanese painting, *nihonga*. Certainly her work, which indicates an aesthetic of decorative pleasure and ordered sensibility, can be seen as coming from a woman's position. There is in it a certain opposition to the position of heroic, male expression in rivalry with the Japanese, which we might see as having been attempted by the contemporary oil painter Yang San-lang (b. 1906). When one compares Chen's work with that of male artists, perhaps we can see it as following, in a Chinese Taiwanese context, the line of the woman painter Uemura Shôen (1875–1949), who had chosen to have a

Three Women Artists from Taiwan

child out of wedlock (unlike Chen Chin, who married). One can sense a determined contiguity between them in formalising the intensity of what women feel from the inside, and not as a function of male projection.

One has to wait until the late 1970s to see women artists such as Lai Jun-jun appear, who had by 1975 finished basic art training and by 1978 had gained a Master of Fine Arts in Japan. Lai comes from an old Taiwanese family whose father had studied at the Taipei Imperial University and had survived the post-war purges of Japanese-trained intelligentsia to be active in the post-retrocession Taiwan film industry. Perhaps the better-off Taiwanese who had survived the influx of Mainlanders could afford younger sons and daughters at art and music schools in the late 1960s and 1970s, before the mainly poorer Mainlander families who survived on official stipends were able to do so.

However, no overall generalisation is possible about the background of women artists. For the poorer or stubbornly independent Taiwanese, like Chen Hsin-wan's father, the distinguished Japanese-trained portrait sculptor Chen Hsia-yu (d. 1918), life could be different. Her history is of a third daughter brought up with a father who shut himself away in purist concentration on his art, in an inner emigration possibly engendered by antipathy to the fate of his generation in post-retrocession Taiwan, and by a mother who had to become the breadwinner of the family. Yet, despite the very real pressures on the surviving Japanese-trained intelligentsia in 1950s and 1960s Taiwan, by the early 1970s, when the artists from Taiwanese families were coming to maturity, any simplistic opposition between Taiwanese and Mainlander families was increasingly invalid for the post-retrocession generation. Chen Hsin-wan was born in Taichung in 1951, Lai Jun-jun at Taipei in 1953, Wu Mali at Taipei in

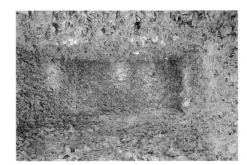

■ *Wu Mali*
Time and space, *1988*
mixed media
1225 x 666 x 360 cm.
Courtesy of
Hsiung Shih Art Monthly.

■ *Chen Hsia-yu*
Nude woman II. *1947*
bronze, height 19 cm.
Collection of
Taipei Fine Arts Museum.

1957. Not only was education in Mandarin universal, but relationships in the art world at least began to be formed across such affiliation boundaries. For example, Chen from provincial Taichung was taught painting at nearby Changhua by Lee Chung-sheng (1911–84) the former mentor of the Eastern painting group, a Mainlander from Guangdong who had also been involved with surrealism in 1930s Japan. She was also to marry the painter Cheng Yan-ping (b. 1951), the son of an impoverished emigré Mainlander who had been an educational official and educated literatus in China, but who worked in Taiwan as head of a rural school.

The other important element which allows, if not in part accounts for, more prominent women artists by the 1980s is the development of a Taiwan modernism itself. This stylistically deprivileged neo-traditional *guohua* and even academy salon oil painting, all of whose senior practitioners were men. One could argue that modernism removed automatic authority for male-sanctioned codes. It is more likely it displaced the notion of a quasi-patriarchal master *(shifu)* with a university-certificated teacher *(laoshi)*, a role which also would be largely filled by men. But these changes, together with more girls in the art-school population and in the audience for art meant that women were not in general as disadvantaged by art institutions as they had been earlier.

One should also note that acceptance of Chen Hsin-wan's mixed media confabulations of textural effects, often with resonances of a woman's relationship to her own physiological states, would not have been stylistically feasible without the opening up of Taiwanese art discourse to modernism by her teacher, Lee Chungsheng. Shortly before he died, Lee praised her anti-academicism, and thought highly of her conceiving painting on the lines of dance, a view which allied with his own tendency towards

finding signs for the pure expression of depth psychology.[1] In however imprecise and sometimes misguided a way, it was Lee who put Taiwanese in contact with surrealist avant-garde practice and notions of automatic writing in the 1950s, long before artists were receiving scholarships to go abroad, chiefly to the United States and Spain, from the mid-1960s in order to gain direct experience of Euro-American modernism for themselves.

The writing and drawing practices of Lai Jun-jun would also not have succeeded without the support of a general tentative move towards a type of minimalism found in the early 1980s by two returnees from Spain, Tsong Pu (b. 1947) and Chen Shih-min (b. 1948), and greatly encouraged by the return of Lin Shou-yu (Richard Lin, b. 1933), who had the international prestige of an older, successful artist then returned from London where he had exhibited with Marlborough.

Even given this context these three artists themselves secured their positions through their own determined exploration. Certainly it was the striking tactile quality of Lai Jun-jun's work in the early 1980s, together with its conceptual agility, which marked it out as expanding into a space made possible by late modernist forms for a woman artist. Lai's work is most complex and multi-faceted, moving from works-on-paper series which deal with an aesthetic of pure touch in the early 1980s, through to the early 1990s in much more jouissant decorative enjoinments of visual pleasure between the movements of calligraphy and the semi-tone shifts of women vocalists for the south Taiwanese *nanguan* music she loves so much. Sometimes she has married this tactile aesthetic with a massive, expansive exploration such as in her multi-panelled black-and-monochrome series which matches a radical conceptual simplicity with a rare ability to visually mobilise reference to touch. Lai also

■ *Chen Chin*
Leisurely, *1935*
ink on silk
136 x 161 cm.
Collection of
Taipei Fine Arts Museum.

works in sculpture, sometimes as wall pieces, sometimes as installations. Of this the Japanese critic Minemura Toshiaki has written: 'The work is not an indiscriminate mixture, but rather a fusion rich in the joy of things which has clearly and distinctly distinguished [sculpture and painting], or has a joyful character at joining these even as she distinguishes them. This character may well suggest great possibilities for the art of today and above all for Asian art which is destined for coexistence and dealings between alien civilizations.'[2]

The same marking out of her own position might be said for Wu Mali who was originally known in Taiwan largely for her translation of Dadaist texts from German, the first into Chinese. For this she was prepared by undergraduate studies in German at Tamkang University before craft studies in Vienna, followed by studies at the Staatliche Kunstakademie, Düsseldorf (1982–86). But in her exhibited work from the late 1980s she demonstrated in a series of brilliant installations, or what she preferred to call 'materials art', and in Dadaist objets, that conceptual understanding, sometimes of a rather cool kind, could be used without heroic masculinist posturings. I do not know if she intended to find meaningful formal analogues to the physical state of womanhood in her Taidong installation in 1988, *Time and space*. But this used enclosed space lit from above and covered with stuck-on crumpled newspapers which it was possible to interpret as a womb metaphor. 'Written signs of poetic intent also become the noise most oppressive to people and this noise circulates from the crumpled newspapers. It makes people feel the process of making the work and the person in making it. Time and space give people their most fundamental experiences.'[3]

There is here a kind of positive poetics of avoidance and enclosure. Its indirect, subtle manifestation is also found in her 1989 floor piece *Literature point zero (wenxue de lingdian)* whose title, taken from Barthes, and the minimal statement of a 1.5 metre square of straw piled more or less evenly to around 15 centimetres, looked like a very ironic statement on the state of modern art in Taiwan. The flat dryness definitely had a note of feminine irony, if not subversion.

Be it the tactile conceptualism of Lai Jun-jun, the quasi-psychonalytical adumbration of texture in the work of Chen Hsin-wan, or the cool and logical play between culture and art discourse of Wu Mali, these artists present us not merely with new dimensions of the relation between Taiwan's culture and modern art practice by women, they almost at a stroke refer to unperceived aspects of wider Chinese culture in its relation to Euro-American modernism, opening up the possibility of such richer intercoding for themselves, as also for us.

■ *John Clark is Senior Lecturer in Japanese in the School of Asian Studies at the University of Sydney. He is editor of* Modernity in Asian Art *(Wild Peony Press, Sydney, 1993).*

NOTES

The Chinese texts of my interviews with Chen Hsin-wan of 6 April 1984 and 30 December 1989; Lai Jun-jun of 27 July 1983, and Wu Mali (with Li Mingsheng) of 2 January 1990 can be found in 'Asian Artist Interview Transcriptions II' Taiwan, 1992, in the libraries of the Australian National University, and the Power Department of Fine Arts, University of Sydney, and elsewhere.

1 Foreword to the catalogue of Chen Hsin-wan's first one-person exhibition at Yihualang, Taipei, 1984.

2 Catalogue of her one-person exhibition at Kakamkura Garô, Tokyo,1991.

3 Meiti, Huanjing, Zhuangzhi, catalogue, (Taiwan Museum of Art, Taidong, 1988), p. 71.

Painting in Taiwan Today

by JOAN STANLEY-BAKER

In today's Taiwan society art collecting has become the conspicuous pastime of many recently wealthied urbanites. Such art collecting among the bourgeoisie is a new endeavour without much foundation or tradition. We see Taipei teeming with expensive little coffee houses, haute couture salons, symphony orchestras and art dealers, all new appendages of the newly affluent. But what is the mindset of this new breed of art collectors? What background in art enjoyment lies behind their conspicuous investments? How, in the innermost spaces of their spiritual dwelling place, do they relate to artworks? Are they transformed by beauty? Are they spiritually empowered or ennobled by what they see and choose? Or do they simply rely on their dealer, as if on a bond salesman: 'Get me the best that money can buy, works by famous artists that will appreciate'?

I ask this because so far there has been little in Taiwan's education system to prepare people for genuine enjoyment of art. Taiwanese students to this day are cautioned by parents (and science teachers) against 'wasting time' in the arts, to get on with the business of earning the grades that would win university entry or a desirable job. In this anti-art atmosphere professional artists in Taiwan have a struggle on their hands. Apart from a single imperial court collection (representing choices of that elite minority), Taiwan is virtually devoid of public museums of folk crafts, Asian, African, European or American arts, or modern art. To broaden their horizons, Taiwanese artists must spend time overseas. The traditionally revered giants of Chinese painting after the Sung dynasty were rarely professional painters, being usually of the official or gentry class, who indulged in art as a spare-time hobby for private enjoyment and were never concerned over 'markets' for their work. Today's artists are following the western model of trying to make a living selling their works in the open marketplace.

But the Taiwanese clients to whom they sell their works do not always appreciate their special qualities. More often than not they are happy to pay high prices – but only for works by an artist who has managed to acquire fame. How is an artist's value established in this environment? New ideas, new images and artistic concepts resound around the world at lightning speed. But what appears to be a universal language of the arts is actually fractured among different cultures, and becomes ever more complex to fathom. We see, for example, the image of Edvard Munch's *The Scream* all over the world, plastered on walls and university bulletin boards from New York to Los Angeles to London, to Athens, Tokyo and Taipei. But can there be an identical underlying meaning behind each of its appearances? What does this image represent for each of the people who put it up? In a sense, it has become a borrowed image, a loose-fitting cap to cover different heads, thus blurring its original shape, size and function. It is more difficult to assess the significance of this image as it appears in different parts of the world than it might have been in the seventeenth century to assess the significance of a Flemish painting of burghers trading in a church interior, or a self-portrait of a Chinese scholar sitting by scrolls and lotuses in a celadon vase.

In the late nineteenth and early twentieth centuries, when Eurocentric imperialist colonies produced landscape paintings in different parts of the world – Canada, Australia, India, Africa and South-East Asia – even though the flora and fauna differed, the underlying value system was intelligible to other Eurocentric viewers, no matter from which part of the world. This is because the genesis and cultural roots of the different images were the same. It is the diaspora of this European stock that has colonised

much of the world, giving the modern global village such a sense of homogeneity. But there is something odd, even false, about such apparent universalism.

Chinese people, whether in Taiwan, the Mainland, or dispersed into different parts of the world, unless they have become culturally absorbed into another sphere, generally retain Chinese values, behaviour and outlook. To this day, Chinese society remains paternalistic, a society that issues injunctions and founds its social mores on Thou Shalt Not. In such a society the Five Relationships exert as much influence on daily life as ever, where no respect is accorded the stranger who is not your ruler, parent, sibling, spouse or friend. The boundaries, dualities and divisions are millennia-firm. We may partake of a universal idiom in our 'mode' of transport and communication. But *what* we communicate is certainly not universal. Our values and attitudes remain very much part of our socialising and our culture. And as long as our culture retains individuality, and we are part of our culture, our authentic artworkers – with genuine value, generated from within our culture – will be different from those of artists of other cultures. A style, or -ism that has true significance and substance is always engendered by the social, political, cultural or climatic condition of a specific locus. Transferred to a second locus, the style or -ism represents aspiration to resemble something in the first locus. We see this when late nineteenth-century Europeans fell under the spell of Japanese lacquers and woodblock prints. Adding these to their love for Chinese porcelains, they produced a style festooned with imported, especially commissioned wallpapers, lacquer cabinets and armorial china, to the point where entire rooms, such as Whistler's Peacock Room, become three-dimensional manifestations of one culture's fantasies of another. The room is suitable only for standing up in, and feels entirely unnatural.

On the other hand, a far more thorough integration of foreign cultural stimuli is achieved when ingredients are first thoroughly adapted or transformed and only then absorbed into one's own culture, such as when European post-impressionist artists incorporated aspects of Japanese *ukiyo-e* woodcuts into their oil painting. Instead of importing Japanese Kabuki actors or Mount Fuji landscapes whole-hog into their canvases, they created a new world of dazzling primary colours applied as flat planes, while still depicting their own chosen subjects. The passion and intensity of the image, as well as the vigour of the application of strokes, are all reflective of the European artist's own cultural traits. Except for occasional direct copies for amusement, European post-impressionists did not imitate Japanese prints or Chinese porcelains, but only adapted essential elements of their respective production to their own use. Thus what we see is European post-impressionism. Gauguin and Van Gogh's works have nothing 'Japanese' or 'oriental' about them, any more than European court dress made of Chinese silks had.

This cannot be said of what Japanese and Chinese artists then did with the European painting they admired in turn. Since the Meiji period Japanese artists, under imported European tutors, have been imitating western oil painting; under Japanese occupation Chinese painters in Taiwan were 'westernised' likewise. Thus blindly imitating a foreign style, copying its techniques and images, they were putting on someone else's dress and speaking their language without knowing the meaning of their words and symbols. Yet many critics and academics are fond of identifying 'styles' with the pride and joy with which children recognise animals in picture books. Styles and -isms are identified by the merest superficial resemblance, without considering their cultural origin or

authenticity. So when what recalls a Warhol painting appears in Japan in the late 1960s – entirely without the cultural conditions that had engendered it in the United States in the early 1950s – pundits proudly proclaim Pop art in its eastern reincarnation, without seeing that its value as an artistic creation is a veneer.

It is interesting in this context to watch how the Taiwan artist Yu Peng interacts with his specific locus, including the local market. Potential buyers will notice in Yu Peng's crowded menagerie first of all the shapes and signs identifiable from their own post-war Taiwan experiences. Yu Peng's art is not detached from ordinary Taiwanese life, but reflects very much the preoccupations of the overwhelming majority of ordinary folk who had been left out in the past. In naming objects in Yu Peng's works, people will recognise with delight lotus and ducks in ponds, lazing water-buffalo, cats, dogs, tamed and exotic animals and fowl, trees and pavilions, box-like high-rises of modern Taiwan, Buddhist icons and figures from other Taoist or folk religions, as well as the low-slung home furnishings that for scholarly viewers will evoke ancient Han China, while reminding the common Taiwan people of the days of Japanese occupation. These outer signs, labels or emblems of a common heritage will satisfy the least tutored Taiwan viewer. Incidentally, such motifs will at the same time excite the western viewer with their 'exoticism'. These ingredients show Yu Peng to be an honest artist, working with the very stuff of which his life is made, and not, like so many of his contemporaries and predecessors, spinning lofty yarns out of thin air in works utterly unrelated to real life, but representing some distant dream (created long ago or far away by someone else). But it is not, in the end, these amusing and casually disported narratives that give Yu Peng his stature or identify his particular flavour. It is in

the *handling* of these motifs that Yu Peng's inner persona unfolds, an internal world that fairly throbs with a sense of tropical life as lush as it is unkempt. The overall tactile quality scratches our inner sensitivity much as a hirsute chin would our tender skin. Whether done as simple sketches, collage, pastel crayons on butcher's paper, oils on canvas, paper or board, or in ink on paper, the noisy, crowded, brushy effect is the same: the pace is lively and dense, exuding always a quality of artless friendliness.

Yu Peng's times are not well ordered. He was born into a Taiwan that, after a series of colonisations by the Spaniards, the Dutch, the Manchus and the Japanese, was at the time coming under Nationalist Chinese domination. Yu Peng grew up learning that his native Taiwanese dialect was beyond the pale, at least in public situations. It is only from the 1980s that native Taiwanese have been allowed to take pride in their rich folk heritage and in their ancient, euphonic dialect with its inimitable expressions. Yu Peng's space has been no less disordered where the once-serene, camphor-lined avenues with ox-cart side lanes have given way to crowded speedways, and where low, black-tiled wooden dwellings skirted with fragrant gardens have been razed for towers of stingy-windowed high-rise apartments that jostle cheek-by-jowl fighting for sunlight.

Yu Peng's wacky clutter and din and the clear, if not actually painful, sense of alienation are all part of the Taiwan of his times. His figures are steeped in solitude: while placed in proximity, each is usually lost in his or her own private world. Deeply involved in the contemporary life around him, like other Taiwanese artists of his generation, Yu Peng has insisted from the beginning on speaking in his own voice and his own manner. In spite of his training in woodcuts, pastels and oils, he has most often chosen to use as his means of

expression the densely overlaid brushwork that comes directly out of the late works of his beloved Huang Binhong (1864–1955), works which, in turn, derive from Ching-dynasty interpretations by masters like Wang Yuanqi (1642–1715) of the Yuan-dynasty master Wang Meng (1301–82). All three painters shared a fear of void or silence and produced works that bristled with brushwork, playing dark against light, straight over curved, wet and dry, building a richly variegated tapestry of abstract, tactile energy.

In Yu Peng's oil paintings the noisy and happy effect originated in his ink-based brushwork is manifested by other means. Here Yu Peng's brush-excitement and tactile energies emerge through the twists and jabs of individual forms, their grouping over a sharply contrasting ground, and the tactile, transparent application of the oils themselves. The particular flavour that had been engendered in traditional ink-based brushwork finds expression here in a medium that the artist has imported and personalised. So in the end, regardless of whether they are genial nudes disporting themselves in Chinese rock gardens or melanges of known and mythical creatures playing on the same plane as in Han-dynasty painting, Yu Peng's oil paintings have a flavour of contemporary Taiwan. Through developing his highly personal traits, Yu Peng has become a full exponent of the contemporary Taiwan scene.

• Material in this essay appeared in the catalogue *Yu Peng: Songs of Innocence and Alienation* (1994).

■ *Joan Stanley-Baker (Hsu Hsiao-hu) is former director of the National Tsing Hua University Arts Centre, Hsinchu, and Professor of Chinese Art History at National Tsing Hua University, Hsinchu, Taiwan.*

■ *Yu Peng*
Studio of the heart: how glad and how discontent!, *1992*
ink and colour on paper (one of a pair of scrolls)
139 x 138.5 cm.
Collection: T.T.Tsui.
Photograph: courtesy Hanart TZ Gallery, Hong Kong.

Art in Southern Taiwan

by HSIAO CHIUNG-JUI

From the time of the Dutch colonialists and the last Ming-dynasty general Cheng Cheng-kung (also known as Koxinga) who expelled them, the Tainan region in southern Taiwan served as Taiwan's political, economic and cultural centre. It was only around 1895, when China ceded Taiwan to Japan as reparation for the Sino-Japanese War, that the Taipei basin, located at the northern end of the island, began to displace Tainan as the island's principal seat of activity. The main reason for this shift was the relative proximity of the northern part of the island to Japan. Japanese ships could land in Keelung in less time but, given Keelung's year-round rainy climate, Taipei became the best choice as a base of island operations.

Taipei's status was enhanced with the establishment of the Japanese governor-general's headquarters there, and, given such a development, it comes as no surprise that the city became the host of the New Art Movement that unfolded to accompany the rise of a new culture. With Japanese planning, Taipei became a modern metropolis. Taipei thus became the centre of Nationalist government operations after 1949. With this decision, the Japanese governor-general's residence, completed in 1919, became the logical choice as the 'temporary' presidential palace of the Republic of China.

As we know, this regime, prepared at all times to return to Mainland China, did not realise its ambitions over the short term. And the choice of Taipei, a sheltered basin located too far north to be an effective centre of operations for the entire island, did not help the island's overall development. Tainan, which had formerly served as the seat of the Ching dynasty's provincial government in Taiwan, progressively lost its voice during the Japanese and post-war periods. With this transition the regional cultural assets accumulated by Tainan over the years

slowly eroded and disappeared.

It would take until the late 1980s before serious deliberation on this situation took place and a consciousness of resistance sprang up in Tainan, and in Kaohsiung (Taiwan's second largest city) further south, as many young artists began working within their own distinctive geographic setting and cultural context. Thus the stage was set for the beginning of a dialogue with Taipei, the city whose voice had long dominated the cultural sphere in Taiwan.

In 1986 an exhibition of modern art entitled the 'New Southern Taiwan Style Exhibition' was held at the Tainan Municipal Cultural Centre. A total of nine young artists from the Kaohsiung and Tainan areas participated, including Huang Hung-teh, Yen Ding-sheng and Lin Horng-wen. The exhibition marked the inauguration of the New Southern Taiwan Style Association, based in Tainan.

The activities of the New Southern Taiwan Style Association differed little from those of other local associations formed over the previous four or five decades, such as the Tainan Art Study Association (founded by Kuo Po-chuan in 1952), the Kaohsiung Art Study Association (founded in 1952 by Liu Chi-hsiang), and the Southern Taiwan Art Study Association which resulted from the merger of the two associations.

Nevertheless, the appearance of the New Southern Taiwan Style Association marked a departure from previous similar associations in that the arrangement of the group's debut show at the 'New Southern Taiwan Style Exhibition' explicitly challenged the cultural consciousness which assumed the primacy of the northern Taiwan style. With this assertion, 'southern Taiwan' was no longer a geographic destination, but became an ideological symbol. In stylistic orientation, these people

no longer merely echoed or reacted to prevailing trends in the Taipei art scene, but instead became autonomous artists intent on conceiving their own stylistic innovations. This was not, of course, a sudden, isolated happening, but an outgrowth of the vitality of new southern Taiwanese society.

Two groups of people emerged in southern Taiwan as a progressive force behind the promotion of art. The first was a group of young modern artists returned from studies abroad who, confronted with the glut of artistic talent in northern Taiwan, made their way back to the south where they had grown up and gone to school. The second group was a collection of young entrepreneurs who had acquired wealth in the construction industry as urban development took off. Motivated by a mixture of investment opportunities, desire to conserve their heritage and personal interest, this group found a natural match in the group of young artists.

The first evidence of this partnership was the establishment in September 1989 of the Yan Huang Art Museum in Kaohsiung, out of which the magazine *Art of China* was published. While the focus was not particularly on contemporary art, it was strongly supportive of the activities of the younger generation of artists. Particularly notable was the contribution of *Art of China* editor Chen Shui-tsai, himself a veteran modernist, whose dedication to establishing a foundation for contemporary art criticism and systemising Taiwan's art history was notable.

At the same time, contemporary artists applied a youthful approach to educational activities such as lectures and seminars designed to promote assorted forms of contemporary art. In May 1991 the Up Gallery, a professional commercial gallery, was established with the support of contemporary artists who used their own

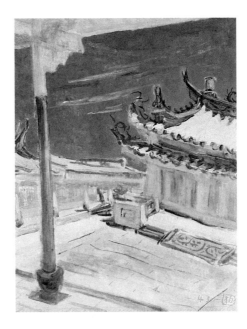

■ *Kuo Po-chuan*
Confucian Temple, *1954*
oil on canvas
43 x 56 cm.
Collection of
Taiwan Museum of Art.

approach to create a space in which they could circulate and make a living.

In April 1992 a group of young graduates from the Chinese Cultural University's art department founded with their own resources an exhibition space they named Marginal Culture, located adjacent to the Tainan Municipal Cultural Centre on Chungming Road. The group's choice of name signified a cultural consciousness in opposition to that of the dominant 'centre'. In one sense, the name Marginal Culture distinguished them from the well-known artists who had already established their place in official exhibition spaces as represented by the cultural centre, so their location in a home near the cultural centre was a natural choice. In another sense they attempted to set themselves apart from Taipei as the centre of art in order to draw attention to Tainan's accustomed status at the island's cultural periphery.

In June 1992 the even larger New Phase Art Space was founded on Yungfu Road in Tainan. From the very outset, this group espoused a modern and local agenda. In its first six months the group sponsored and held the 'New Cultural Icons of Southern Taiwan' exhibition. The sponsors made it clear that the aim of this exhibition was to help establish a 'local artistic look' unique to southern Taiwan. Participating artists included Huang Pu-ching, Chang Hsin-pei, Wu Mei-sung, Ni Tsai-chin, Su Chih-cheh, Chen Lung-hsing, Huang Hung-teh, Li Chun-hsien, Lee Ming-tse, Wu Kuan-ying, Yen Ding-sheng, and Lin Horng-wen. The group's 1993 exhibition, 'Eras and Images – A Grand View of the Development of Tainan City Modern Art', illustrated even more clearly how these participants had devoted themselves to refashioning the evolution of a local artistic style.

From the preceding introduction, perhaps we can see that the rise of contemporary art in southern Taiwan in the late 1980s did not entirely come out of an ideological call for autonomy, but was also boosted by the overall vitality of society, particularly its economic strength. Neither did it suffer from the strategic orchestration of selected artists or of the art market.

The majority of artists who emerged on the historical stage during this movement were natives of southern Taiwan who grew up under the hot sun there, or who over the course of their work discovered a strong identification with the region. Given the circumstances of the time, they were no longer willing or forced to choose Taipei as their only option for realising their artistic aspirations. As a result they gained confidence and creative drive. And as 'facts dictate reality', a formerly subtle regional style gradually took shape and surfaced from their continued activities and artistic pursuits. A wilder, rawer, truer and more powerful style emerges from the works of these southern Taiwanese artists: a lively, sly, spontaneous patchwork.

Underneath the spontaneous, easy exterior of the work of Tainan artists such as Yen Ding-sheng, Huang Hung-teh, and Lin Horng-wen lies a lonely, isolated character which at the same time contains deep reflection on nature and humanity and conveys a sense of intimacy with the land. This contrasts starkly with the robust working-class worldliness of Kaohsiung's Modern Painting Association. Lee Ming-tse meanwhile is simultaneously naive and culturally sophisticated.

A high-speed railway system is in store for Taiwan, which will make it possible to travel from Taipei to Kaohsiung in between forty-five and sixty minutes. This railway will eliminate the feeling of time and space that accompanies the four-hour journey between the two cities on the north–south highway completed in the 1970s. The

cities of Taiwan, – neither a particularly large nor small island, – will perhaps one day be separated by geography only, rather than by uneven development. The question of 'southern Taiwan' may thus prove to be a transitional issue only.

TRANSLATED BY
David Toman

■ *Hsiao Chiung-jui is Lecturer in the Department of History, National Cheng-kung University, Tainan.*

■ *New Phase Art Space, Tainan. (top and bottom)*

HOU CHUN-MING
Erotic paradise, 1992
woodblock prints

Text Translations

1. AGGRESSION
In the aimless drifting of
exile any effort is to no avail,
but you should still maintain
an attitude of defence.

2. THE WANDERER
When you go out into the
world and find no place to
rest you should do more and
more good deeds no matter
how trivial. If you have no
wife then anyone can be
your wife.

3. REBIRTH
If you separate yourself
from women you'll become
withered and haggard and
die. Only through the
profound union of the sexual
rite can one be reborn.

4. HYPOCRISY
Don't be afraid of your
desires, life's true meaning
lies in using good and honest
images to make a positive
realisation of them.

5. SELF IMMOLATION
Those who are protective of
themselves will always have
difficulties in self-realisation.
You must go through trials
of fire and water and have the
courage to open yourself up.

6. SEEKING PLEASURE
No-one can have a real
understanding of what you
are doing, but you should
still try to understand and
cherish one another.

7. DOING EVIL
Searching for and not
finding love is the greatest
humiliation and frustration
in one's life, but love's pain
is sweeter than all the
happiness in the world.

8. LONELY AND COLD
Sharing the spirit is difficult
and sharing the flesh is
dangerous. You should learn
how to derive pleasure from
being by yourself.

Translated by
Jamie Greenbaum

1

2

3

4

自焚圖

極樂圖懺（貳）

〔釋文〕自我保護者永難自我完成你當赴湯蹈火勇於付出

行樂圖

極樂圖懺（壹）

〔釋文〕沒有人能真切的明白你在做什麼但你們仍應相知相惜

造孽圖

極樂圖懺（陸）

〔釋文〕求愛不得是一輩子最大的屈辱與折難但愛的痛苦卻仍甜過世上所有的歡樂

孤寒圖

極樂圖懺（伍）

〔釋文〕心靈的分享是困難的肉身的共享是危險的你當學習自處自得其樂

5 6 7 8

13

CHENG TSAI-TUNG
You and I toast, why
surprise? 1993
oil on canvas

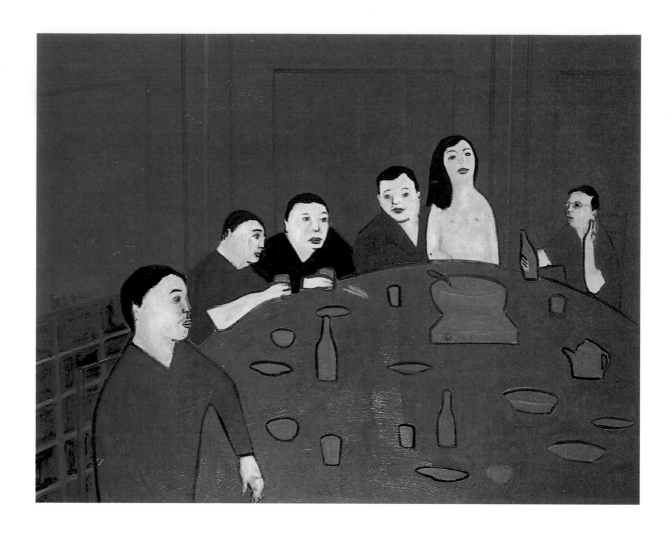

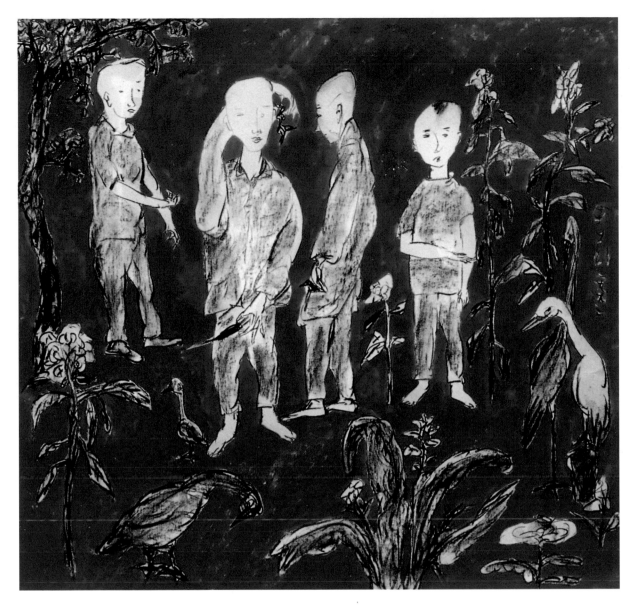

14
YU PENG
Endless windy moon, 1993
oil on rice paper (detail)

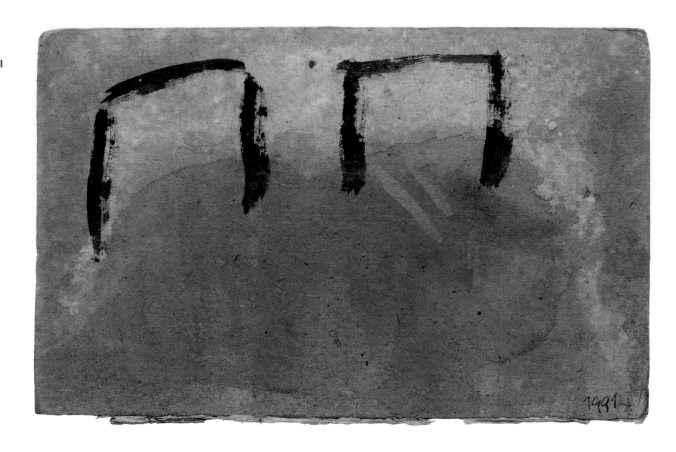

15
HUANG HUNG-TEH
Magnet and child, 1991
ink and watercolour on
cardboard

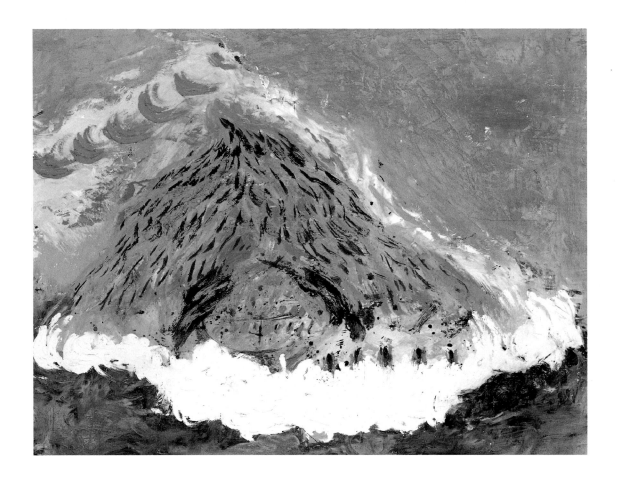

16
YEN DING-SHENG
Mountain – I, 1989
acrylic and magnetic clay

YEN DING-SHENG
Spinning dragonfly, 1991
mixed media

17
LIN HORNG-WEN
The other kind of feeling,
1992
mixed media

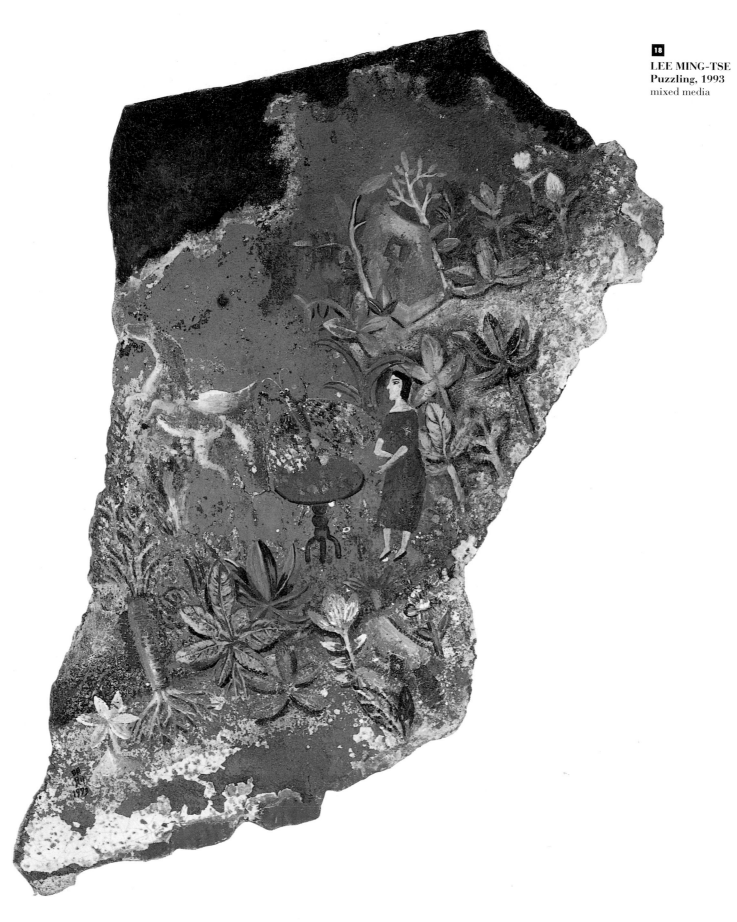

MARGARET SHIU TAN
Floating, 1991
ceramic and mixed media
installation

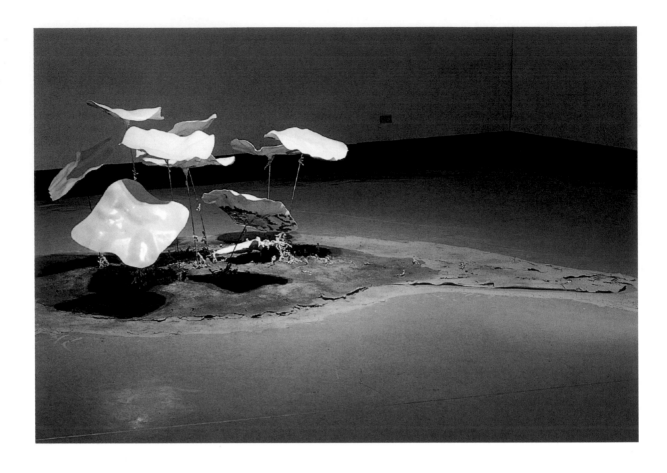

20
LAI JUN-JUN
Wind, 1990
wood and graphite

CHEN HUI-CHIAO
Silent picture, 1992
mixed media

TSONG PU
The trembling lines, 1984
mixed media

23
CHEN HSIN-WAN
In search for life, 1992
ink on paper (details)

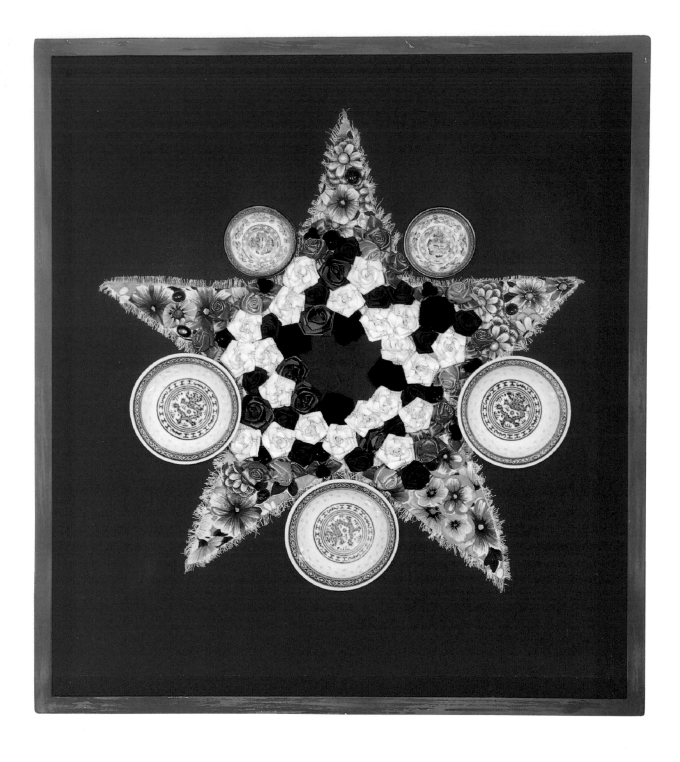

YAN MING-HUY
Three apples, 1988
oil on canvas

CHANG YUNG-TSUN
Transformation and
installation of a changing
melody, 1984–88
paper, paint, ink,
plastic boxes

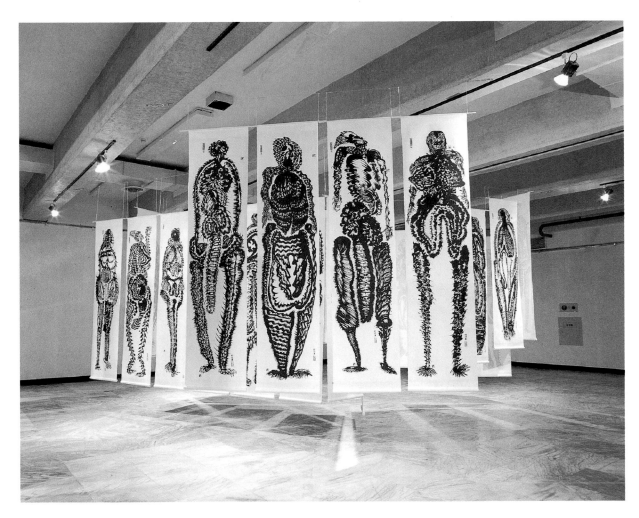

27
HUANG CHIH-YANG
Hsiao maternity room,
1993
ink on paper scrolls

28

CHIU TSE-YAN
Dreamland of night walk,
1993
charcoal on paper

29
LIEN CHIEN-HSING
**The lioness in deep
thought, 1990**
oil on canvas

CHU CHIA-HUA
Camel and fruit, 1993
mixed media

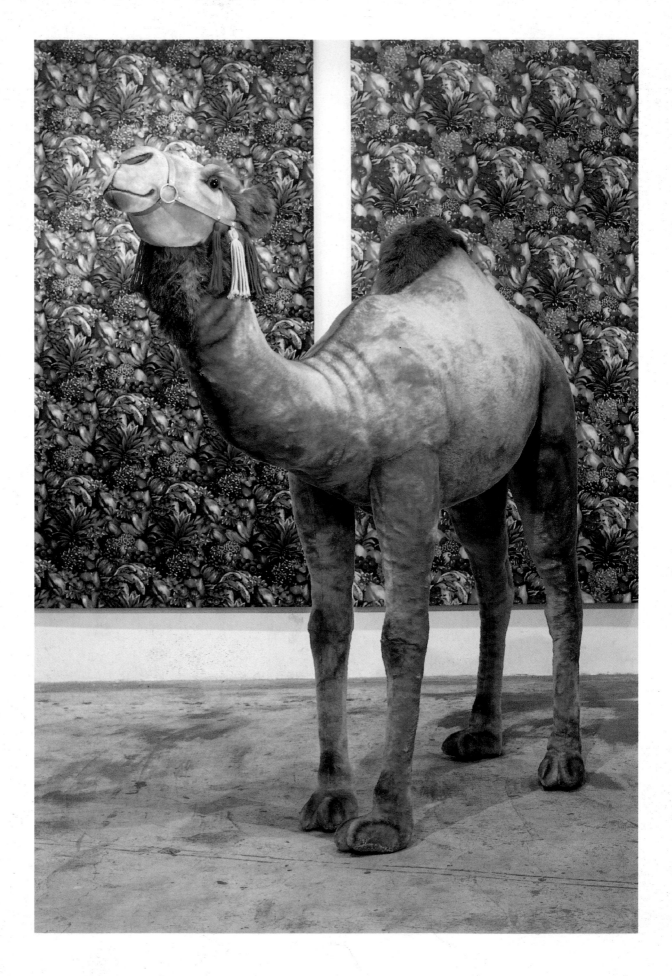

List of Colour Plates

Artists' Biographies

Bibliography

Colour plates

1 **YANG MAO-LIN (b. 1953)**
**Zeelandia memorandum
L9301, 1993**
oil and acrylic on canvas
112 x 194 cm
Collection of
Taipei Fine Arts Museum

2 **WU TIEN-CHANG (b. 1956)**
**About the government of
Chiang Kai-shek, 1990**
('Portraits of the Emperors'
series)
oil on linen
310 x 330 cm
Collection of Willington Lee

WU TIEN-CHANG (b. 1956)
**About the government of
Mao Tse-tung, 1990**
('Portraits of the Emperors'
series)
oil on linen
310 x 330 cm
Wen-shew collection

3 **HUANG CHIN-HO (b. 1956)**
Fire, 1991–92
oil on canvas
400 x 815 cm
Collection of the artist

4 **FAN CHIANG MING-TAO
(b. 1955)**
Dignity of green, 1993
gilded ceramics, grass
320 x 240 x 120 cm
Collection of the artist

5 **WU MALI (b. 1957)**
Prosperity car, 1991
mixed media
334 x 128 x 136 cm
Collection of the artist

6 **LU MI (b. 1961)**
**Wandering around the earth,
1993**
mixed media installation
variable dimensions
Wen-shew collection

7 **KU SHIH-YUNG (b. 1960)**
Home land, foreign land, 1993
mixed media
600 x 300 x 100 cm
Collection of the artist

8 **MEI DEAN-E (b. 1954)**
**Silk Road – Brocade China,
1993**
mixed media installation
variable dimensions
Collection of the artist

9 **LU HSIEN-MING (b. 1959)**
Morning in Taipei, 1992
oil on linen
269 x 395 cm
Collection of Taipei Fine Arts
Museum

10 **LIEN TEH-CHENG (b. 1957)**
Confucius says, 1992
mixed media
132 x 320 cm
Collection of the artist

11 **KUO JEN-CHANG (b. 1946)**
Day for night I-I, 1992
acrylic on canvas
194 x 260 cm
Collection of Willington Lee

12 **HOU CHUN-MING (b. 1963)**
Erotic paradise, 1992
woodblock prints
102.5 x 79 cm (x 8)
Collection of the artist

13 **CHENG TSAI-TUNG (b. 1953)**
**You and I toast, why surprise?
1993**
oil on canvas
80 x 100 cm
Collection of Hanart (Taipei)
Gallery

14 **YU PENG (b. 1955)**
Endless windy moon, 1993
oil on rice paper
70 x 70 cm (detail)
Collection of Taipei Fine Arts
Museum and Hanart (Taipei)
Gallery

15 **HUANG HUNG-TEH (b. 1956)**
Magnet and child, 1991
ink and watercolour on
cardboard
14.5 x 21 cm
Private Collection

16 **YEN DING-SHENG (b. 1960)**
Mountain – I, 1989
acrylic and magnetic clay
72 x 90 cm
Collection of Wu Ching-you

YEN DING-SHENG (b. 1960)
Spinning dragonfly, 1991
mixed media
60.5 x 70.5 cm
Collection of Chen Chuen-hsing

17 LIN HORNG-WEN (b. 1961)
The other kind of feeling, 1992
mixed media
35 x 39 cm
Private Collection

18 LEE MING-TSE (b. 1957)
Puzzling, 1993
mixed media
70 x 53 cm
Private Collection

19 MARGARET SHIU TAN
(b. 1946)
Floating, 1991
ceramic and mixed media
installation
300 x 180 x 90 cm
Collection of the artist

20 LAI JUN-JUN (b. 1953)
Wind, 1990
wood and graphite
71 x 55 cm
Collection of
Taipei Fine Arts Museum

21 CHEN HUI-CHIAO (b. 1964)
Silent picture, 1992
mixed media
150 x 180 x 6 cm
Collection of Margaret Shiu Tan

22 TSONG PU (b. 1947)
The trembling lines, 1984
mixed media
262 x 192 cm
Collection of
Taipei Fine Arts Museum

23 CHEN HSIN-WAN (b. 1951)
In search for life, 1992
ink on paper
110 x 70 cm (details)
Collection of the artist

24 HOU YI-REN (b. 1958)
Wommunism I plates, 1992
mixed media
48.5 x 54.5 cm
Collection of the artist

25 YAN MING-HUY (b. 1956)
Three apples, 1988
oil on canvas
100 x 100 cm
Collection of Heritage Arts
International

26 CHANG YUNG-TSUN (b. 1957)
Transformation and
installation of a changing
melody, 1984–88
paper, paint, ink, plastic boxes
50 x 50 x 5 cm (x 9)
Collection of Taipei Fine Arts
Museum

27 HUANG CHIH-YANG (b. 1965)
Hsiao maternity room, 1993
ink on paper scrolls
60 x 240 (each) (10 scrolls)
Collection of the artist

28 CHIU TSE-YAN (b. 1961)
Dreamland of night walk, 1993
charcoal on paper
75 x 100 cm
Collection of Council for Cultural
Planning and Development

29 LIEN CHIEN-HSING (b. 1962)
The lioness in deep thought,
1990
oil on canvas
130 x 234 cm
Collection of Wu Ching-you

30 CHU CHIA-HUA (b. 1960)
Camel and fruit, 1993
mixed media
variable dimensions
Collection of the artist

Artists' Biographies

KUO JEN-CHANG　郭振昌

1946　Born in Lukang, Taiwan
1967–73　Studied in the Lee Chun-sheng Studio
1973　Graduated from Fine Art Department of Chinese Culture University

SOLO EXHIBITIONS
1969　Tien Chin Hall, Taipei
1973　Morrison Art Gallery, Taipei
1973　Hung Ling Art Gallery, Taipei
1979　Graphic Artists' Gallery, Taipei
1987　Asia World Art Centre, Taipei
1987　Changhua County Culture Centre
1991　'Modernization, Modern Painting', Crown Art Centre, Taipei
1992　'Sensational Black Line – Modern Chinese Plastic Art', Contemporary Art Centre, Taichung
1993　'The Phenomena of the Mythical Age', Lung Men Art Gallery, Taipei
1993　'The Phenomena of the Mythical Age', Up Art Gallery, Taipei
1993　Up Art Gallery, Kaohsiung
1994　'J.C. Kuo's Icons and Images of Taiwan', Galerie Elegance, Taipei

SELECTED GROUP EXHIBITIONS
1973　'Graphic Art', Hung Ling Art Gallery, Taipei
1974　'Graphic Art', Chu Pao Pot Art Gallery, Taipei
1977　'Joint Exhibition of Chen Ting-Sh and Kuo Jen-chang' U.S.I.S. Lincoln Centre, Taipei
1985　'Sino-Philippine Modern Art Exhibition', Asia World Art Centre, Taipei
1986　'The Second Sino-Korean Modern Painting Exchange Exhibition', Kuan Thing Art Museum, Seoul
1986　'Taipei Modern Art 1986 Exhibition', Hong Kong Art Centre, Hong Kong
1986　'The New Look of Chinese Modern Art 1987', National Museum of History, Taipei
1987　'The Second Asian International Art Exhibition', National Museum of History, Taipei
1987　'Chinese Contemporary Paintings', National Museum of Contemporary Art, Seoul
1988　'The Third Asian International Art Exhibition', National Museum Art Gallery, Fukuoka

1989　Los Angeles Art Centre, Los Angeles
1989　'Message From Taipei', Hara Museum ARC, Tokyo
1990　'From Tradition to Innovation', Yung Han Gallery Innovation Exhibition, Taipei
1990　'The Fifth Asian International Art Exhibition', Kuala Lumpur
1991　'The International Public Collection Asia Modern Art Exhibition', Ueno Royal Museum, Tokyo
1991　'The Joint Exhibition of Wu Hao, Kuo Jen-chang and Ku Chung-kuang', Crown Art Centre, Taipei
1991　'Encountering the Others', Kassel
1993　'1993 International Contemporary Art Exposition', Yokohama

MARGARET SHIU TAN　蕭麗虹

1946　Born in Hong Kong
1969　Graduated, University of California, Berkeley

SOLO EXHIBITIONS
1986　'Movements in Nature', American Cultural Centre, Taipei
1991　'Two Worlds', Taipei Fine Arts Museum
1992　'Process and Experience' Installation Exhibition, National Tsing Hua University
1993　'Cloud's Observations' I T Park, Taipei
1993　'Free as the Sky …' Howard Plaza, Taipei

SELECTED GROUP EXHIBITIONS
1984　'Sino-Japanese Art Exchange', Taipei Fine Arts Museum
1984　'Special Exhibition of Ceramic Art in China', Taiwan Provincial Museum
1985　'International Ceramics Exhibition', Taipei Fine Arts Museum
1986　'Second Contemporary Chinese Sculpture in the Republic Of China', Taipei Fine Arts Museum
1986　'First Chinese Ceramics Biennial Exhibition', National Museum of History, Taipei
1986　'First International Ceramic Competition, 86', Mino, Japan

1987　'45 Concorso, International della Ceramic d'arte', Faenza (juried)

1987　'Experimental Art-Action and Space', Taipei Fine Arts Museum (juried)

1988　'Contemporary Ceramics from the Republic of China', travelling exhibition to Belgium and West Germany

1988　'Hong Kong Modern Art Competition, 1988', Philippe Charriol Foundation, Hong Kong

1988　'Contemporary Art Trends in the Republic of China 1988', Taipei Fine Arts Museum

1988　'Second Chinese Biennial Ceramic Exhibition', National Museum of History, Taipei

1989　'Chinese Contemporary Ceramics', National Museum of History, Taipei

1989　'Contemporary Sculpture in the Republic Of China 1989', Taipei Fine Arts Museum

1990　'Third International Exhibition of Small Ceramics', Zagreb (juried)

1990　'Arts Support '90', Hong Kong Art Centre

1990　'Third Chinese Ceramic Biennial Exhibition', National Museum of History, Taipei

1990　'Contemporary Taiwan Ceramics', travelling exhibition to the USA, organised by the National Museum of History, Taipei

1991　'TERRA – Eleven Clay Artists', Taipei Fine Arts Museum

1992　'The Taipei Biennial of Contemporary Art', Taipei Fine Arts Museum

1992　'Study on Four Decades of Ceramics in Taiwan', Taiwan Museum of Art, Taichung

1992　'Chinese Contemporary Ceramic Art', Kulturhistorisches Museum, Magdeburg

1992　'International Invitational Exhibition of Contemporary Ceramic Art', National Museum of History, Taipei

1993　'Fifth Chinese Ceramic Biennial Exhibition', National Museum of History, Taipei

1993　'Taiwan Art: 1945–1993', Taipei Fine Arts Museum

TSONG PU　莊　普

1947　Born in Shanghai

1969　Graduated from Fu-Shing Commerce & Industry High School, Taipei

1978　Graduated from La Escuela Superior de Bellas Artes de San Fernando de Madrid, Spain

1981　Returned to Taiwan

SOLO EXHIBITIONS

1983　'A Meeting of Mind and Material', Spring Gallery, Taipei and San-Chai Gallery, Taichung

1985　'Temptation After Meeting by Chance', Spring Gallery, Taipei and Ming-Men Gallery, Taichung

1989　'A Tree, A Stone, and A Piece of Cloud', Kuenca Gallery, Spain

1990　'The Space Between Body and Soul', Taipei Fine Arts Musuem

1991　Up Art Gallery, Kaohsiung

1993　'Love Never Dies', I T Park Gallery, Taipei

SELECTED GROUP EXHIBITIONS

1979　'Contemporary Overseas Chinese Artists', National Museum of History, Taipei

1979　'Three-Man Exhibition', Rincon de Arte Gallery and Busgan Gallery, Spain

1979　'Group Exhibition of Chinese Artists in Europe', Kienlong Gallery, Brussels

1980　'Two-Man Exhibition', Sala de Exposiciones de La Delegacion Provincial de Turismo, Santander

1982　'Three-Man Exhibition', Spring Gallery, Taipei

1983　'Taipei Fine Arts Museum Opening Exhibition', Taipei Fine Arts Museum

1984　'Difference in Space', Spring Gallery, Taipei

1985　'Taipei Hsiung Shih Biennial Exhibition', Hsiung Shih Gallery, Taipei

1985　'Beyond Space', Spring Gallery, Taipei

1986　'Contemporary Art Trends in the Republic Of China', Taipei Fine Arts Museum

1986　'The Invitational Exhibition from the International Modern Arts Association Japan', Yokohama

1987　'Chinese Contemporary Paintings', National Museum of Contemporary Art, Seoul

1987　'Avant-Garde Installation Space', Taipei Fine Arts Museum

1987 'Chinese Contemporary Paintings', National
 Museum of History, Taipei
1988 'Time and the Unprecedented: Contemporary
 Art in the Republic Of China', Taipei Fine Arts
 Museum
1988 'Two-Man Exhibition', Cherng Pin Gallery,
 Taipei
1988 'Media-Environment-Installation', Taiwan
 Museum of Art, Taichung
1989 'Message from Taipei', Hara Museum ARC,
 Tokyo
1990 'Sketching Exhibition', Cherng Pin Gallery,
 Taipei
1990 'Up Art Gallery Opening Exhibition', Up Art
 Gallery, Kaohsiung
1990 'Poems and the New Environment', Cherng Pin
 Gallery, Taipei
1991 'The Space Between the Metaphysical and the
 Material', Up Art Gallery, Kaohsiung
1991 'Contemporary Art Trends in the Republic Of
 China', Leisure Art Centre, Taipei
1991 'International Mail Art Exhibition', I T Park
 Gallery, Taipei
1992 'Taiwania Gallery Opening Exhibition',
 Taiwania Gallery, Taipei
1992 'Taipei Biennial of Contemporary Art', Taipei
 Fine Arts Museum
1993 'Culture of Gift Giving', New Phase Art Space,
 Tainan
1993 'Prosperous Every Year', Galerie Pierre,
 Taichung
1993 Tsong Pu – Lai Jun-jun – Hul Kun-jung, Three-
 Artist Exhibition', I T Park Gallery, Taipei
1993 'Stopping the World', I T Park Gallery, Taipei
1994 'The Indescribable Unknown – The I T Park
 Fund Raising Exhibition', I T Park Gallery,
 Taipei

CHEN HSIN-WAN 陳幸婉

1951 Born in Taichung, Taiwan
1972 Graduated from the National Taiwan Academy
 of Arts

SOLO EXHIBITIONS

1984 One Gallery, Taipei
1989 Lung Men Art Gallery, Taipei
1989 Contemporary Art Gallery, Taichung
1990 Taiwan Museum of Art, Taichung
1991 Galerie Mashrabia, Cairo, Egypt
1992 Yong Han International Art Centre, Taipei
1992 Cité des Arts, Paris
1993 Galerie King Brick, Taichung

SELECTED GROUP EXHIBITIONS

1975 Summer Art Association, Taichung
1982–89 Current Focus Art Association, Taichung
1984 'Separated Space Exhibition', Spring Gallery,
 Taipei
1987 National Museum of History, Taipei
1987 'The New Look of Chinese Modern Art',
 National Museum of History, Taipei
1987 'Chinese Contemporary Paintings', National
 Museum of Contemporary Art, Seoul
1988 'The Third Asian International Art Exhibition',
 National Fukuoka Museum of Contemporary
 Art, Japan
1988 'The Exhibition of Art Development in the
 Republic Of China', Taiwan Museum of Art,
 Taichung
1988 'Time and the Unprecedented: Contemporary
 Art in the Republic of China', Taipei Fine Arts
 Museum
1989 'Message from Taipei', Hara Museum ARC,
 Tokyo
1990 Artists' Studio, Basel, Switzerland
1991 Spectre Abstrait, Yuon-Han Centre d'Art
 International, Taipei
1992 Cité des Arts, Paris

CHENG TSAI-TUNG　鄭在東

1953　Born in Taipei

SOLO EXHIBITIONS

1980　American Cultural Centre, Taipei
1981　American Cultural Centre, Taipei
1983　Wisteria Teahouse, Taipei
1984　Hanart 2 Gallery, Hong Kong
1986　The Empty House, Taipei
1986　Taichung Cultural Centre, Taichung
1987　Sherkat Gallery, East Village, New York
1988　Yuan Nung Teahouse, Taipei
1988　Wisteria Teahouse, Taipei
1990　Hanart (Taipei) Gallery, Taipei
1991　Hanart (Taipei) Gallery, Taipei
1992　Hanart (Taipei) Gallery, Taipei

SELECTED GROUP EXHIBITIONS

1984　'New Painters from Taiwan', Hanart 2 Gallery, Hong Kong
1985　'Taiwan New Painting', Spring Gallery, Taipei
1986　'Cheng Tsai-Tung & Chiu Ya-Tsai', Howard Salon, Taipei
1986　'Taiwan-Korea Exhibition', National Museum of History, Taipei
1988　'Contemporary Ink Painting', National Museum of History, Taipei
1988　'Cheng Tsai-Tung and Chiu Ya-Tsai', Hanart 2 Gallery, Hong Kong
1988　'October Group Exhibition', Yunhan Art Centre, Taipei
1989　'Contemporary Art Works Exhibition', National Museum of History, Taipei
1991　'Individualist Movement', Hong Kong Art Centre, Hong Kong
1992　'Dis/Continuity', Taipei Fine Arts Museum

LAI JUN-JUN　賴純純

1953　Born in Taipei
1974　Graduated, Chinese Culture University, Taiwan
1977　Graduated, Master of Arts, Tama Art University, Japan

SOLO EXHIBITIONS

1977　Kunugi Gallery, Tokyo
1978　Hwa-Kang Museum, Taipei
1980　Chinese Culture Centre, New York
1981　American Cultural Centre, Taipei
1982　Hwa-Kang Museum, Taipei
1983　Lung Men Art Gallery, Taipei
1986　Spring Gallery, Taipei
1988　Taipei Fine Arts Museum
1988　CMS Gewerbehaus, IAAB, Basel
1989　Galerie Simone Gogniat, Basel
1990　Ateliers de Laguepie, Laguepie, France
1991　Kamakura Gallery, Tokyo
1991　Nabis Gallery, Tokyo
1991　Mincher/Wilcox Gallery, San Francisco
1992　Cherng Pin Gallery, Taipei
1992　I T Park Gallery, Taipei

SELECTED GROUP EXHIBITIONS

1981　'International Print Exhibit', Hong Kong Arts Centre
1983　'International Biennial Print Exhibition', Taipei Fine Arts Musuem
1984　'East Culture' Aichi – Ken City Gallery, Japan
1985　'International Biennial Print Exhibition', Taipei Fine Arts Museum
1985　'Avant-Garde/Installation/Space', Taipei Fine Arts Museum
1986　'Contemporary Sculpture Competition', Taipei Fine Arts Museum
1986　'International Exhibition', Japan International Arts Association, Japan
1987　'Chinese Contemporary Art', National Contemporary Art Museum, Seoul
1987　'Experiment/Action/Space', Taipei Fine Arts Museum
1988　'Six Persons', Galerie Simone Gogniat, Basel
1988　'Environment and Installations', Taiwan Museum of Art
1988　'Time and Creation Exhibition', Taipei Fine Arts Museum
1989　'Artists of Taiwan and LA', Taiwan Museum of Art, Taichung

1989	'Message From Taipei', Hara Museum ARC, Tokyo
1989	'Contemporary New Arts', National Museum of History, Taipei
1990	Yong Han Gallery, Taipei
1990	'Sixth Annual Juried Women's Art Exhibit', Guadeloupe
1990	Cultural Arts Centre, San Antonio, Texas
1990	'Four Persons', LA Art Core, Los Angeles
1990	'Chair Series I', Howard Plaza, Taipei
1992	'Artist from CA', Macao Museum, Macao
1992	'Jun Lai's Works', Kamakura Gallery, Tokyo
1993	'Women's Art', Junyong Gallery, Taipei
1993	'Four Persons Exhibition', I T Park, Taipei

YANG MAO-LIN 楊茂林

1953	Born in Changhua, Taiwan
1979	Graduated from Fine Arts Department Chinese Culture University

SOLO EXHIBITIONS

1986	'101 Yang Mao-lin One Man Show', Taichung Culture Centre
1987	'Behaviour of Game', Taipei Fine Arts Museum
1990	'Made in Taiwan-I', Taipei Fine Arts Museum
1991	'101 Yang Mao-lin One Man Show', Taiwan Museum of Art, Taichung
1992	'Made in Taiwan – II', Hsiung Shih Gallery, Taipei
1992	'Made in Taiwan – II Memorandum Section II', Galerie Pierre, Taichung
1992	'Made in Taiwan – II Memorandum Section II', Taiwania Gallery, Taipei
1993	'Yang Mao-lin 1986–1993', Doors Art Space, Kaohsiung
1993	'Zeelandia Memorandum', Galerie Pierre, Taichung

SELECTED GROUP EXHIBITIONS

1983	'101 Modern Art Group Exhibition', American Cultural Centre, Taipei and Multi-Media Art Square, Kaohsiung
1984	'The First Modern Painting Group Exhibition in the Republic Of China', Taipei Fine Arts Museum

1985	'New Painting Exhibition', Taipei Fine Arts Museum
1985	Kunsan International Arts Exhibition, South Korea
1985	'Alternative Arts Exhibition of Chinese & Korean Modern Painting', South Korea
1986	'Contemporary Art Trends in the Republic Of China', Taipei Fine Arts Museum
1986	'New Face of Modern Painting in the Republic Of China', National Museum of History, Taipei
1986	'Style 22 Exhibition', Taipei Fine Arts Museum
1986	'Exhibition of New Representational Painting', Taipei Fine Arts Museum
1986	'Group Exhibition of '86 Modern Arts', Hwanya Art Centre, Taipei
1987	'Asian International Arts Exhibition', National Museum of History, Taipei
1987	'Chinese Contemporary Arts Exhibition', National Contemporary Art Museum, Seoul
1987	'Chinese Art Development Exhibition', Taiwan Museum of Art, Taichung
1987	'Chinese Contemporary Painting Show', San Francisco
1988	'Exhibition of Contemporary Art Trends in the Republic Of China', Taipei Fine Arts Museum
1988	'This Era & Creative Art', Taipei Fine Arts Museum
1988	'Exhibition of Postmodern Painting', Kaohsiung Culture Centre
1989	'Message From Taipei', Hara Museum ARC, Tokyo
1989	'National Contemporary Arts Exhibition', Kaohsiung Culture Centre
1990	'300 Years of Fine Arts in Taiwan', Taiwan Museum of Art, Taichung
1990	'101 Modern Art Group Exhibition', Windsor Collections, Taipei
1990	'Fifth International Contemporary Arts Exhibition', Kuala Lumpur
1991	'Social Observation – The New Art Trends in Taiwan', Hsiung Shih Gallery, Taipei
1991	'The Power Wind of Taipei', Galleria Gallery, Seoul
1991	'27th Asia Modern Art Exhibition', Ueno Royal Museum, Tokyo
1991	'Taipei Art Group Exhibition', Mu-Shi-Yuan Gallery, Taipei

1992	'The Power of Taiwan', Taipei Art Group, Taipei Fine Arts Museum
1992	Opening Exhibition – 'New Phase of Taiwanese Arts', New Phase Space, Tainan
1993	'TIAS', Tokyo
1993	Art Export, Chicago
1993	'Historical Novel of Iconography', Doors Art Space, Kaohsiung
1993	'Taiwan Art: 1945–1993', Taipei Fine Arts Museum
1993	'Eighth International Contemporary Arts Exhibition', Fukuoka
1993	'The New Record of Warring States', New Phase Art Space, Taiwan

MEI DEAN-E 梅丁衍

1954	Born in Taipei
1977	Graduated, Department of Fine Arts, Chinese Culture University
1985	Graduated, Master of Fine Arts, Graduate School of New York, Pratt Institution, New York

SOLO EXHIBITIONS

1980	Lung Men Art Gallery, Taipei
1985	Pratt Institution Art Gallery, New York
1989	Taiwan Museum of Art, Taichung
1989	Taipei Fine Arts Museum
1991	Western & Eastern University, New Jersey
1991	Mei Hua Art Centre, New York
1992	Cherng Pin Gallery, Taipei
1992	Galerie Pierre, Taichung
1992	The First Gallery, New York

SELECTED GROUP EXHIBITIONS

1977	'Switzerland International Graphic Art Exhibition', Switzerland
1980	'International Graphic Art Exhibition', South Korea
1980	'Sino-American Modern Graphic Art Exchange Exhibition', American Cultural Centre, Taipei
1981	'Hsiung Shih New Promising Artists Prize', National Museum of History, Taipei
1982	'Chinese Modern Graphic Art Exhibition', University of St John's, New York
1983	'National Chinese Graphic Art Exhibition', Taipei Fine Arts Museum

1983	'Ten Youths Graphic Art Exhibition', New Jersey
1984	'Pratt Rage Exhibition', Willard Gallery, New York
1985	'Petite Work Exhibition', New York
1986	'Eleven New York Overseas Painters Joint Exhibition', Howard Salon, Taipei, Hong Kong Art Centre and Canton Art Centre
1988	'Four Image Exhibition', Mei Hua Art Centre, New York
1989	Chiu Tai Art Gallery, New York
1989	'Workshop 220, Three Artists Exhibition', New York
1990	'Annual Exhibition, Asian American Art Centre', New York
1990	'AIDS Totem', New York
1991	'Community Culture', Harbor Bureau Culture Centre, New York
1991	'Asian Artists Appeal to the AIDS Crisis', New York
1991	'Taipei/New York Modern Art Encounter', Taipei Fine Arts Museum, New York Culture Centre
1991	'Object Racial Prejudice', City University, New York
1992	'Individualism, The Third Order: A Show of True Strength', Capital Art, Taichung
1992	'Palace of Art', New York
1992	'Strangeness Exhibition', Artists Space, New York
1992	'Friends of Ling-Ling', City University, New York

FAN CHIANG MING-TAO 范姜明道

1955 Born in Taipei
1982 Graduated, Woodbury University, Los Angeles
1984 Graduated, Master of Arts, California State University, Los Angeles
1987 Graduated, Master of Fine Arts, Otis Parson School of Art, Los Angeles

SOLO EXHIBITIONS

1984 California State University Art Gallery, Los Angeles
1987 Otis Art Institute Gallery, Los Angeles
1988 Pottery Lovers, Taipei
1990 Space II, Taipei
1991 Space II, Taipei
1993 GoGo Gallery, Tainan

SELECTED GROUP EXHIBITIONS

1984 Pasadena Art Association Gallery, Pasadena
1985 Whiteley Art Gallery, Los Angeles
1986 'Three Artists Joint Exhibition', Otis Art Institute Gallery, Los Angeles
1987 'Five Artists Joint Exhibition', Craft and Folk Art Museum, Los Angeles
1987–88 'Tea Utensils Exhibition', Garth Clark Gallery, Los Angeles and Los Angeles International Airport
1989 Artistart Gallery, Arizona
1990 'Eleven Artists Exhibition', Taipei Fine Arts Museum
1991 Arizona Modern Art Museum

YU PENG 于 彭

1955 Born in Taipei
1971–80 Studied watercolour, drawing, ink painting and shadow puppetry with various masters

SOLO EXHIBITIONS

1980 Autumn Garden Gallery, Taipei
1985 Artist Gallery, Taipei
1988 Tianmu Ceramic Studio, Taipei
1989 Hanart (Taipei) Gallery
1989 Hanart 2 Gallery, Hong Kong
1990 Hanart Gallery, New York
1991 Hanart (Taipei) Gallery
1991 Asian Arts Centre, Towson State University, Maryland
1992 'Literati Dreams', Hanart T Z Gallery, Hong Kong
1992 Hanart (Taipei) Gallery
1993 Hanart (Taipei) Gallery; Gallery Yang, Germany

SELECTED GROUP EXHIBITIONS

1981 Athens
1982 'Expressionism: 3 Artists', Shangya Gallery, Taipei
1984 'Shuangxi Stone Sculpture Exhibition', Baijia Art Gallery, Taipei, and Sancai Art Centre, Taichung
1988 Hanart 2 Gallery, Hong Kong
1990 Wisteria Teahouse, Taiwan; Golden Stone Gallery, Taichung
1992 'Encountering the Others', Kassel
1992 'Joint China-Korea Exhibition of Contemporary Ink Painting', Seoul
1993 'Contemporary Chinese Ink Painting', Leningrad State Museum
1994 'Man and Earth: Contemporary Paintings from Taiwan', Centre for the Visual Arts, Metropolitan State College of Denver

HUANG CHIN-HO 黃進河

1956 Born in Chiayi County, Taiwan
1985 Graduated, National Chung-hsing University

SOLO EXHIBITIONS
1990 First Exhibition in Workshop, Railroad Factory
 No. 15, Taichung
1991 Mu Shih Yuan Art Gallery, Taipei

SELECTED GROUP EXHIBITIONS
1992 'Encountering the Others', Kassel

HUANG HUNG-TEH 黃宏德

1956 Born in Tainan, Taiwan
1983 Graduated, National Taiwan Academy of Arts

SOLO EXHIBITIONS
1990 Tainan Municipal Cultural Centre
1990 Up Gallery, Kaohsiung
1991 Cherng Pin Gallery, Taipei
1991 I T Park, Taipei
1991 Go Go Gallery, Tainan
1992 I T Park, Taipei
1992 Go Go Gallery, Tainan
1993 Up Gallery, Kaohsiung
1993 Cherng Pin Gallery, Taipei

SELECTED GROUP EXHIBITIONS
1986 'New Style Painting Society', Tainan Municipal
 Cultural Centre
1986 'Modern Youth Art Exhibition in Hawaii',
 East-West Cultural Centre, Honolulu
1986 'Works on Paper', National Museum of Modern
 Art, Brazil
1987 'Three Man Show', Spring Gallery, Taipei
1987 'Exhibition of Modern Painting from the
 Republic of China', National Contemporary Art
 Museum, Seoul
1988 'New Style Painting Society', Tainan Municipal
 Cultural Centre
1988 'Contemporary Art Works Exhibition from the
 Republic of China', The Egyptian Museum,
 San Francisco
1989 'Time and the Unprecedented: Contemporary
 Art in the Republic Of China', Taipei Fine Arts
 Museum

1990 'Contemporary Drawing Exhibition', Cherng Pin
 Gallery, Taipei
1990 'Opening Group Show', Up Gallery, Kaohsiung
1991 'Three-person Joint Exhibition: Between the
 Metaphysical and the Physical', Up Gallery,
 Kaohsiung
1992 'Dis/Continuity', Taipei Fine Arts Museum
1992 'New Style Painting Society of Southern
 Taiwan', Biennial Exhibition, Tainan City
 Culture Centre
1992 Joint Exhibition of Up Artists, King Stone
 Gallery, Taichung
1992 New Artists Five-Person Joint Exhibition,
 Cherng Pin Gallery, Taipei
1992 'New Cultural Image of Southern Taiwan',
 New Phase Art Space, Tainan
1993 'In Exile', Up Gallery, Kaohsiung

WU TIEN-CHANG 吳天章

1956 Born in Changhua, Taiwan
1980 Graduated, Department of Fine Arts, Chinese
 Culture University

SOLO EXHIBITIONS
1987 'Syndrome of Hurting', Taipei Fine Arts Museum
1990 Taipei Fine Arts Museum

SELECTED GROUP EXHIBITIONS
1983 '101 Modern Art Group Exhibition', American
 Cultural Centre, Taipei
1983 Multi-Media Art Square, Kaohsiung
1984 'The First Modern Painting Group Exhibition in
 the Republic Of China', Taipei Fine Arts Museum
1984 'Contemporary Trends in Chinese Art', Taipei
 Fine Arts Museum
1985 'Exhibition of Contemporary Chinese Prints',
 New Aspect Arts Centre, Taipei
1985 'The Eighth Prints Exhibition in the Republic Of
 China', Taipei
1985 'New Painting Exhibition', Taipei Fine Arts
 Museum
1985 'The First Art exhibition by Taipei Painting
 Group', Domestic Art Exhibition Centre, Taipei
1986 'Contemporary Art Trends in the Republic Of
 China', Taipei Fine Arts Museum

1986 'Exhibition of Modern Painting's New Appearance in the Republic Of China', National Museum of History, Taipei

1986 'Style 22 Exhibition', Taipei Fine Arts Museum

1987 'Modern Paintings Exhibition', Domestic Art Exhibition Centre, Taipei

1987 'Asian International Arts Exhibition', National Museum of History, Taipei

1988 'Exhibition of Contemporary Art Trends in the Republic Of China', Taipei Fine Arts Museum

1988 'Time and the Unprecedented: Contemporary Art in the Republic Of China', Taipei Fine Arts Museum

1989 'The Art Exhibition by Taipei Painting Group', Taipei Fine Arts Museum

1989 'Message from Taipei', Hara Museum ARC, Tokyo

1992 'Encountering the Others', Kassel

1994 'Taipei Biennial of Contemporary Art Exhibition', Taipei Fine Arts Museum

1994 'Post-martial law – Conceptual Approach', Shyuan-men Art Centre, Taipei

YAN MIN-HUY　嚴明惠

1956 Born in Pu-Tze, Taiwan

1970 Graduated, National Taiwan Normal University

1987 Graduated, Master of Arts, New York State University, Albany

SOLO EXHIBITIONS

1987 SUNY-Albany Art Gallery, Albany

1990 Galerie l'Age d'Or, Taipei

1990 Kingstone Gallery, Taichung

SELECTED GROUP EXHIBITIONS

1989 Textile Design, Gallery of FIT, USA

1990 'Praise of Spring Group Show', Jee-Jung Gallery, Taipei

1990 Women's Awakening Association, Taipei

1991 Joint Exhibition of Three Women Artists, Taipei

CHANG YUNG-TSUN　張永村

1957 Born in Changhua, Taiwan

1988 Graduated, Department of Fine Arts, National Taiwan Normal University

SOLO EXHIBITIONS

1981 'The Leap of Civilisation', Spring Gallery, Taipei

1983 'Modern Texture', Lung Men Gallery, Taipei

1986 '0-1', Spring Gallery, Taipei

1988 'Transformation and Installation', Asian Art Centre, Taipei

JOINT EXHIBITIONS

1984 'Contemporary Abstract Painting', Taipei Fine Arts Museum

1984 'The Play of Space', Spring Art Gallery, Taipei

1985 'Avant-Garde/Installation/Space', Taipei Fine Arts Museum

1985 'Beyond the Space', Spring Gallery, Taipei

1986 'Contemporary Art Trends in the Republic of China 1986', Taipei Fine Arts Museum

1987 'Environment Art/Action/Space', Taipei Fine Arts Museum

1987 'Behaviour and Space', Taipei Fine Arts Museum

1988 'Transcendimensional-Space', Taipei, Taichung and Kaohsiung

1988 'Media/Environment/Installation', Taiwan Museum of Art, Taichung

1989 'Time and the Unprecedented: Contemporary Art in the Republic of China', Taipei Fine Arts Museum

1989 'Message From Taipei', Hara Museum ARC, Tokyo

1990 'Screw the Mass Media', ROXY II Pub, Taipei. Performance art on the courtyard of the Chiang Kai-shek Memorial Hall.

1993 'The Ee-Du-Space Exhibition – Omnidirectional Being & Transforming', Taipei Fine Arts Museum

LEE MING-TSE　李明則

1957　Born in Kaohsiung County, Taiwan
1977　Graduated from high school

SOLO EXHIBITIONS

1984　American Cultural Centre, Taipei
1986　K.H.S., Taipei
1988　Tien-Mu Pottery, Taipei
1991　Chungate Art Centre, Kaohsiung
1991　'Modern Art (II)', Up Gallery, Kaohsiung
1993　Galerie Pierre, Taichung
1993　Chungate Art Centre, Kaohsiung

SELECTED GROUP EXHIBITIONS

1992　Chungate Art Centre, Kaohsiung
1992　Go Go Gallery, Tainan
1992　'Contemporary Graffiti', Chungate Art Centre, Kaohsiung
1992　'New Phase Art of Taiwan', New Phase Art Space, Tainan
1992　'Dis/Continuity', Taipei Fine Arts Museum
1992　New Phase Art Space, Tainan
1993　'Contemporary Art in Taiwan', G. Zen 50 Gallery, Kaohsiung
1993　'Time and Image', New Phase Art Space, Tainan
1993　'Taiwan Art: 1945 1993', Taipei Fine Arts Museum

LIEN TEH-CHENG　連德誠

1957　Born in Taipei
1979　Graduated, Department of Fine Arts, National Taiwan Normal University
1983　Graduated, Master of Fine Arts, University of North Carolina at Greensboro

SOLO EXHIBITIONS

1986　Nan Gallery, Taipei
1987　Nan Gallery, Taipei
1989　Space II, Taipei
1990　Taipei Fine Arts Museum
1991　Space II, Taipei
1993　Space II, Taipei
1993　Up Gallery, Taipei

SELECTED GROUP EXHIBITIONS

1984　'Greensboro Art League, Annual Show', Moreheads Galleries, Greensboro, North Carolina
1988　'The Third Asian International Art Exhibition', Japan
1988　'The Art Development Exhibition in the Republic Of China', Taiwan Museum of Art, Taichung
1989　'Contemporary Artwork Exhibition', National Museum of History, Taipei
1989　'Lin Tung-lin and Lien Teh-cheng – Two Artist Exhibition', Top Gallery, Taipei
1989　'The Fifth Asian International Art Exhibition', Seoul City Art Museum, Seoul
1990　'Visual Exhibition', Cherng Pin Gallery, Taipei
1990　'300 Years of Fine Arts in Taiwan', Taiwan Museum of Art, Taichung
1991　'Social Observation', Hsiung Shih Art Gallery, Taipei
1991　'Strange Force, Mass, Deity', Taiwan Document Room, Mou Yeh Art Gallery, Taipei
1991　'Art/Experiment – 1991 Apartment Exhibition', Taipei Fine Arts Museum
1991　'Origin, Earth and Sex', Space II, Taipei
1992　Inauguration Exhibition, Taiwania Gallery, Taipei
1992　'Selling Point', GoGo Gallery, Tainan
1992　'Taiwan Art New Ecology', New Phase Art Space, Tainan
1992　'Artists Book', American Cultural Centre, Taipei
1993　'Petite Special Exhibition', Up Gallery, Taipei
1993　'Petite Oeuvres', Up Gallery, Kaohsiung

WU MALI 吳瑪俐

1957 Born in Taipei
1986 Graduated, National Academy of Arts, Dusseldorf

SOLO EXHIBITIONS

1985 'Newspaper Space', Shen-Yu Gallery, Taipei
1986 'Game Is Not Yet Ended', Spring Gallery, Taipei
1987 'Vanishing Point', Chiang-Zen Gallery, Taipei
1988 'Paradoxical Number', Ho Ping East Road Workshop, Taipei
1991 'Tidbits', Contemporary Art Gallery, Taichung
1992 Eagle Aesthetics Contemporary Art Gallery, Taichung
1993 I T Park, Taipei, River Art Centre, Taichung and New Phase Art Space, Tainan

SELECTED GROUP EXHIBITIONS

1988 'Media Environment Installation', Taiwan Museum of Arts
1989 '520, New Peitou Train Station Contemporary Art Exhibition of the Republic of China', National Museum of History International Art Festival, Japan
1990 Exhibition to Celebrate the Inauguration of President Lee, Taiwan Document Room, Taipei Recycle Scene, Hanart (Taipei) Gallery
1991 'Grotesque Superstition', Taiwan Document Room, Taipei Society Observation, Hsiung Shih Art Gallery, Taipei Pro Automo Dimensions Art Gallery, Taipei
1992 Art Exposition Artist Book, American Cultural Centre, Taipei

HOU YI-REN 侯宜人

1958 Born in Taichung
1980 Graduated from National Taiwan Normal University
1987 Graduated from Pratt Institute with MFA Degree

SOLO EXHIBITIONS

1991 Space II, Taipei
1993 Space II, Taipei

GROUP EXHIBITIONS

1990 Two person exhibition, American Cultural Centre, Taipei
1991 Dimension Art Centre, Taipei
1991 Four Women exhibition at King Stone Gallery, Taichung
1992 Top Gallery, Taipei
1992 Galerie Pierre, Taichung
1992 Capital Art, Taichung
1992 'Artists' Books', American Cultural Centre, Taipei
1992 River Art Centre, Taipei
1993 'Women Artists of 1993', Jun Yeong Art Gallery, Taipei
1993 Shoebox sculpture exhibition, The Gallery, Taipei

LU HSIEN-MING　陸先銘

1959 Born in Taipei
1982 Graduated, Department of Fine Arts, Chinese
 Culture University

SOLO EXHIBITIONS
1985 Chiang Ren Gallery
1993 Taiwan Art Gallery

SELECTED GROUP EXHIBITIONS
1982 'Inventive Artists Exhibition', Today Gallery,
 Taipei
1984 'Modern Abstract Exhibition', Taipei Fine Arts
 Museum
1985 'Ten Years Retrospective Exhibition of Inventive
 Artists', Hsiung Shih Art Gallery, Taipei
1985 '1985 New Painting Exhibition', Taipei Fine
 Arts Museum
1986 'Contemporary Art Trends in the Republic of
 China', Taipei Fine Arts Museum
1986 'Second Sino-Korean Modern Painting Exchange
 Exhibition', Taipei County Cultural Centre
1986 'Style 22 Exhibition', Taipei Fine Arts Museum
1986 'New Representative Exhibition', Taipei Fine
 Arts Museum
1987 'The New Outlook of Contemporary Painting of
 the Republic of China', Museum of History,
 Taipei
1987 'Pusan Youth Biennial Exhibition', Pusan
1987 'Third Sino-Korean Modern Painting Exchange
 Exhibition', Seoul
1988 'Art Development Exhibition of the Republic Of
 China', Taiwan Museum of Art
1988 'Contemporary Art Trends In the Republic Of
 China', Taipei Fine Arts Museum
1989 'Taipei Painting School Exhibition', Taipei Fine
 Arts Museum
1989 'Sino-Korean Modern Painting Exchange
 Exhibition', Seoul
1990 'Contemporary Art Trends in the Republic Of
 China', Taipei Fine Arts Museum
1992 'Sixth Asian International Art Exhibition', Japan
1992 'Inauguration Exhibition', Taiwania Gallery,
 Taipei
1992 'Concerning Taiwan Poster Exhibition', I T Park
 Gallery, Taipei
1992 'Taipei Painting School in Taichung', Modern
 Art Gallery, Taichung

1992 'Taiwan Art of the End of the 20th Century',
 Modern Art Space, Taichung
1992 'Seventh Asian International Art Exhibition',
 Indonesia
1993 'Red Enzyme', Taiwan Gallery, Taipei
1993 'The Art Exhibition toward Apex', G Zen 50 Art
 Gallery, Kaohsiung
1993 'New Art, New Tribes – Taiwan Art in the
 Nineties', Hanart (Taipei) Gallery
1993 'Taiwan Art: 1945–1993', Taipei Fine Arts
 Museum
1993 'The Eighth Asian International Art Exhibition',
 Japan

CHU CHIA-HUA　朱嘉樺

1960 Born in Hsinchu, Taiwan
1982 Graduated, National Taiwan Academy of Arts
1990 Graduated, Master of Arts, National Art
 Academy, Milan

SOLO EXHIBITIONS
1991 Veder Gallery, Milan
1992 I T Park Gallery, Taipei
1993 Taipei Fine Arts Museum

SELECTED GROUP EXHIBITIONS
1989 Veder Gallery, Milan
1990 San Fedele Gallery, Milan
1991 La Bottega Dei Vasai Gallery, Milan
1991 The Second International Logos Exhibition,
 Italy
1991 Raynold Art Space Gallery, Rome
1992 Taipei Art Fair
1992 'The White Paper of Artists', I T Park Gallery,
 Taipei
1992 'Individualism, The Third Order: A Show of
 True Strength', Capital Art, Taichung
1992 'It-Kitsch – Love Gift', I T Park Gallery, Taipei
1993 'The Subtropical Plant', Cherng Pin Gallery,
 Taipei; Galerie Pierre, Taichung
1993 'Biennial Exhibition', Up Art Gallery, Taipei
1993 'Access to the Summit', Kaohsiung

KU SHIH-YUNG 顧世勇

1960　Born in Changhua, Taiwan
1983　Graduated, National Taiwan Academy of Arts
1990　Graduated, Ecole Nationale Superieure de
　　　Creation Industrielle de Paris
1991　Graduated, Ecole Nationale Superieure d'Arts
　　　Decoratifs de Paris
1991　Maitrise d'arts Plastiques, Universite de Paris I,
　　　Pantheon-Sorbonne

SOLO EXHIBITIONS

1992　'Flying Roof, Visiting', I T Park Gallery, Taipei
1992　'Paris, Interval', Taiwan Museum of Art,
　　　Taichung
1993　Up Gallery, Taipei
1993　River Art Center, Taichung

SELECTED GROUP EXHIBITIONS

1986　'Sprinkle, Human Modern Art', American
　　　Cultural Centre, Taipei
1987　'Behaviour and Space: Experimental Art', Taipei
　　　Fine Arts Museum
1990　Contemporary Art Exhibition, la Chapelle de la
　　　Salpeterie, Paris
1991　'Young Artists Exhibition', Grand Palais, Paris
1991　'Young Artists Exhibition', Courbevoie City
　　　Cultural Centre, Castle Equilly, France
1991　'Decouvertes 1991', Grand Palais, Paris
1991　'Installation in Bookstore', Cherng Pin Gallery,
　　　Taipei
1991　'The International Post Art Exhibition', I T Park
　　　Gallery, Taipei
1992　'Begin from the Object', I T Park Gallery, Taipei
1992　'The Taipei Biennial of Contemporary Art',
　　　Taipei Fine Arts Museum
1992　'Young Artists of Paris', Grand Palais, Paris
1992　'Wearing Concept: The Charity Sale of
　　　Realisation', I T Park Gallery, Taipei
1992　'Art Fair', Song Shan Foreign Trade Association,
　　　Taipei
1992　'It – Kitsch, Love Gift', I T Park Gallery, Taipei
1993　'The Subtropical Plant', Cherng Pin Gallery,
　　　Taipei
1993　'International Youth Painting Exhibition',
　　　Grand Palais, Paris

YEN DING-SHENG 顏頂生

1960　Born in Tainan, Taiwan
1983　Graduate, National Taiwan Academy of Arts

SOLO EXHIBITIONS

1989　Tainan Municipal Cultural Centre
1990　Up Gallery, Kaohsiung
1991　Cherng-Pin Gallery, Taipei
1993　Cherng-Pin Gallery, Taipei
1994　Faremate Gallery, Taipei

SELECTED GROUP EXHIBITIONS

1986　'Modern Chinese Paintings New Prospect
　　　Exhibition', Taipei Fine Arts Museum
1986　'New Style Painting Society', Tainan Municipal
　　　Cultural Centre
1987　Korean International Biennial Young Artists
　　　Exhibition, South Korea
1988　'Modern Chinese Paintings New Prospect
　　　Exhibition', Taipei Fine Arts Museum
1988　'New Style Painting Society', Taipei Fine Arts
　　　Museum, Tainan Municipal Cultural Centre
1989　Selected Contemporary Artists Series Exhibition,
　　　Cherng Pin Gallery, Taipei
1990　'New Style Art Biennial, Southern Taiwan',
　　　Kaohsiung Municipal Cultural Centre
1992　'New Style Art Biennial, Southern Taiwan',
　　　Tainan Municipal Cultural Centre
1992　'Dis/Continuity', Taipei Fine Arts Museum

CHIU TSE-YAN 邱紫媛

1961 Born in Pin-ton, Taiwan
1984 Graduated, National Taiwan Normal University, Taipei

SOLO EXHIBITIONS
1992 Taiwan Gallery, Taipei

SELECTED GROUP EXHIBITIONS
1989 Eisner Gallery, City College/CUNY, New York
1989 Harlem Museum, New York
1990 Hunter Gallery, New York
1990 Aron Davis Hall, City College/CUNY, New York
1991 Bronx Museum of Art, New York
1991 'Artist In The Marketplace – Eleventh Annual Exhibition'

LIN HORNG-WEN 林鴻文

1961 Born in Tainan, Taiwan
1982 Graduated, National Taiwan Academy of Arts

SOLO EXHIBITIONS
1990 Dimensions Art Centre, Taipei
1992 New Phase Art Space
1992 Municipal Cultural Centre, Tainan
1993 Galerie Pierre, Taichung

SELECTED GROUP EXHIBITIONS
1984 'Contemporary Art Trends in the Republic of China', Taipei Fine Arts Museum
1985 'Contemporary Abstract Painting', Taipei Fine Arts Museum
1985 'Hsiung Shih New Artists Prize', National Museum of History Republic Of China, Taipei
1986 'Contemporary Art Trends in the Republic Of China', Taipei Fine Arts Museum
1986 'Art in Southern Taiwan', Municipal Cultural Centre, Tainan
1986 'Modern Art of Young Generation in the Republic of China', Hawaii
1987 'New Faces of Modern Painting', National Museum of History Republic Of China, Taipei
1987 Exchange exhibition, Kuan-Hsuin Museum, South Korea
1987 'Unlimited '87', Municipal Cultural Centre, Tainan

1988 'Contemporary Art Trends in the Republic Of China', Taipei Fine Arts Museum
1990 'Contemporary Art Trends in the Republic Of China', Taipei
1991 Opening Show, GoGo Gallery, Tainan
1992 Southern Taiwan New Style Shuang Nian Show, Municipal Cultural Centre, Tainan
1993 'Contemporary Art in Taiwan', G Zen 50 Art, Kaohsiung
1993 'Time and Images', New Phase Art Space, Tainan
1993 'Concourse II', Municipal Cultural Centre, Tainan

LU MI 魯宓

1961 Born in Taipei
1985 Graduated from the Art Department, National Normal University
1992–93 The Glassell Scholarship Art Museum of Texas, Houston

SOLO EXHIBTIONS
1993 I T Park, Taipei

SELECTED GROUP EXHIBITIONS
1986 Second Contemporary Sculpture Biennial, Taipei Fine Arts Museum
1990 I T Park opening exhibition
1990 'Lazy Pictures', Mexic-Arte Gallery, Austin, Texas
1990 A.A.A.C. Annual Exhibition, Asian-American Arts Centre, New York
1993 'The Core Show', Glassell School of Art, Houston, Texas
1993 'Texas Dialogues', Houston, San Antonio, Texas

LIEN CHIEN-HSING　連建興

1962　Born in Keelung
1984　Graduated, Painting Department of Prival
　　　Cultural University

SOLO EXHIBITIONS

1984　'Thirst for looking far away to the sky', Today
　　　Gallery, Taipei
1991　Two-person exhibition, Cherng Pin Gallery,
　　　Taipei
1993　Cherng Pin Gallery, Taipei

SELECTED GROUP EXHIBITIONS

1984　'First Republic Of China New Prospect
　　　Exhibition of Modern Paintings', Taipei Fine
　　　Arts Museum
1984　'The Sensibility to Civilisation – Taipei
　　　Progressionists Modern Art Group', American
　　　Cultural Centre, Taipei
1984　'Cultural Interchange Exhibition of the Republic
　　　Of China and Japan', Kariya Fine Arts Museum,
　　　Japan
1986　'New Form Exhibition', Taipei Fine Arts
　　　Museum
1986　'New Look Exhibition of Modern Art', National
　　　Museum of History, Taipei
1987　Joint Exhibition of the winners of Shyi Der-Jinn
　　　Memorial Prize, National Museum of History,
　　　Taipei
1987　'New Painting Exhibition', Gwo-Chaan Art
　　　Centre, Taipei
1987　'Third Modern Painting Interchange Exhibition
　　　of the Republic Of China and South Korea',
　　　County Cultural Centre, Taipei and Kuan Hsan
　　　Fine Art Museum, Seoul
1988　'Extracts on Trial', Howard Salon, Taipei
1988　'The Republic Of China Fine Arts Development
　　　Exhibition', Taiwan Provincial Fine Arts
　　　Museum
1989　Taipei Painting Group Exhibition, Taipei Fine
　　　Arts Museum
1992　'Sixth Asian International Fine Arts Exhibition',
　　　Tagawa Fine Arts Museum

HOU CHUN-MING　侯俊明

1963　Born in Chiayi, Taiwan
1987　Graduated, National Institute of Art, Taiwan

SOLO EXHIBITIONS

1988　'Eating Moon, The Little Woman' installation
　　　work, Yong Han Gallery
1990　'Hall of the Great', 'Penalty Sky', Taiwan
　　　Document Room
1990　'Desire Punishment', City Art Gallery, Hong
　　　Kong
1990　'Five Coloured Compass' (Ancient Trample
　　　Theatre Installation), National Theatre, Taipei
1990　'Pusan International Biennial Exhibition', Pusan
1990　'Sweeping the Colourful Stream Water Falling
　　　on the Ground', U-Theatre
1990　'The Legend of Mr Hou', National Institute of
　　　Art, Taipei
1991　'The Wedding of Hou Family', Dignity Gallery,
　　　Taipei
1991　'Taiwan Aboriginal Dance & Music Series: the
　　　Bunu Chapter', Stage Installation Design,
　　　National Theatre, Taipei
1991　'Tiger Candidate', U-Theatre
1992　'Re-metamorphosis of Penalty Sky', outside
　　　installation, 228 Community Consciousness
　　　Week, Taiwan University
1992　'Resentful Soul', Space II, Taipei
1992　'Regretting Painting of Divine Joy', Up Art
　　　Gallery
1992　'Sad Spirit', Space II Gallery, Taipei
1992　'Erotic Paradise Relief', Up Art Gallery,
　　　Kaohsiung
1992　'Warring Spirit' (fifteen parts in one piece), I T
　　　Park Gallery, Taipei
1993　'Collecting Spirits', Hsiung Shih Gallery, Taipei
1993　New Trends Gallery, Taichung; New Phase Art
　　　Space, Tainan

SELECTED GROUP EXHIBITIONS

1991　'Observation of Society', Hsiung Shih Gallery,
　　　Taipei
1992　'Taipei Biennial Exhibition', Taipei Fine Arts
　　　Museum
1992　'Dis/Continuity', Taipei Fine Arts Museum
1992　'Art Fair–1992', CETRA Exhibition Hall, Taipei
1992　'Individualism, The Third Order: A Show of
　　　True Strength', Capital Art, Taichung
1993　'Adherent Mind', Hanart (Taipei) Gallery

CHEN HUI-CHIAO 陳慧嶠

1964 Born in Tanshui, Taiwan
1982 Graduated from Yu-Te Fine Arts High School, Taipei

SOLO EXHIBITIONS

1992 I T Park Gallery, Taipei
1994 I T Park Gallery, Taipei

SELECTED GROUP EXHIBITIONS

1987 'Avant-Garde Installation Space', Taipei Fine Arts Museum
1990 'I T Park Gallery Opening Exhibition', I T Park Gallery, Taipei
1990 'Fifth Pusan International Biennial', Pusan Culture Centre Art Hall, Pusan
1990 'Twelve-person Contemporary Painting Exhibition', Dimensions Art Gallery, Taipei
1991 'Sorcery Exhibition', I T Park Gallery, Taipei
1991 'Taiwan Contemporary Female Artists Exhibition', Lung Men Art Gallery, Taipei
1991 'The Circumstance of Reading', I T Park Gallery, Taipei
1991 'Group Exhibition of Contemporary Painting', Dimensions Art Gallery, Taipei
1991 'International Mail Art Exhibition', I T Park Gallery, Taipei
1992 'Exhibition of Paper Works', Howard Salon, Taipei
1992 'Beginning from the Object', I T Park Gallery, Taipei
1992 'The Taipei Biennial of Contemporary Art', Taipei Fine Arts Museum
1992 'Environment & Art – 16 Ideas for Rubbish Handling', Taipei Municipal Cultural Centre, Taipei
1992 'Wearing Apparel: The Conception', I T Park Gallery, Taipei
1992 'Artists' Books', American Cultural Centre, Taipei
1992 'IT Kitsch-Love Gift', I T Park Gallery, Taipei
1993 'Culture of Gift Giving', New Phase Art Space, Tainan
1994 'Prosperous Every Year', Galerie Pierre, Taichung
1993 'New Year Exhibition', Up Art Gallery, Taipei
1993 'Female Artists Joint Exhibition', Jun Yeong Art Gallery, Taipei
1993 'The Subtropical Plant', The Eslite Vision, Taipei and Galerie Piere, Taichung
1993 'An Idea About Flowers', I T Park Gallery, Taipei
1993 'New Art, New Tribes: Taiwan Art in the Nineties', Hanart (Taipei) Gallery, Taipei
1993 '8/8 (Pa Pa) Exhibition', The Gallery, Taipei
1994 'The Indescribable Unknown – The I T Park Fund Raising Exhibition', I T Park Gallery, Taipei; Hanart TZ Gallery, Hong Kong; Gate Gallery, Taipei.

HUANG CHIH-YANG 黃志陽

1965 Born in Taipei
1989 Graduated, Department of Fine Arts, Chinese Culture University

SOLO EXHIBITIONS

1990 Space II, Taipei
1991 Top Gallery, Taipei
1992 Space II, Taipei

SELECTED GROUP EXHIBITIONS

1989 'Sino-Korean Modern Ink Painting Exhibition', Seoul
1989 'The Zeitgeist of Ink and Colour', Taipei Fine Arts Museum
1990 'Fifth International Graphic Biennial', Taipei Fine Arts Museum
1990 'Sino-Korean Modern Ink Painting Exhibition', Taipei
1991 'Art/Experiment – 1991 Apartment Exhibition', Taipei Fine Arts Museum
1991 'Origin, Earth and Sex', Space II, Taipei; GoGo Gallery, Tainan and Up Gallery, Kaohsiung
1992 'Selling Point', GoGo Gallery, Tainan
1992 'Environment Art Exhibition', Taipei County Cultural Centre, Taiwania Gallery, Taipei
1992 'Dis/Continuity', Taipei Fine Arts Museum
1992 'Individualism, The Third Order: A Show of True Strength', Capital Art, Taichung

Bibliography

- *Art and AsiaPacific*, quarterly journal (Fine Arts Press, Sydney).

- *Artist Magazine (Yishujia)* (Artist Publishing House, Taipei).

- *Art Monthly (Yishu Guizu)* (Yishu Guizu Publishing House, Taipei).

- *Asian Art News*, bi-monthly (Asian Art News Ltd, Hong Kong).

- Chang Tsong-zung (curator), *Man and Earth: Contemporary Paintings from Taiwan* (Centre for the Visual Arts, Metropolitan State College of Denver, Colorado, 1994).

- Cheng Ming-chuan (ed.), *New Phase Art of Taiwan* (New Phase Art Space, Tainan, 1992).

- Cheng Ming-chuan (ed.), *A Survey of Taiwan Women's Culture (Taiwan nuxing wenhua guancha)* (New Phase Art Space, Tainan, 1994).

- *Dragon Art Monthly (Yanhuang Meishu)* (Yanhuang Museum of Art, Kaohsiung).

- *Free China Review*, vol. 43, no. 3, March 1993 (Kwang Hua Publishing USA, Los Angeles).

- W. G. Goddard, *Formosa: A Study in Chinese History* (Macmillan, London, 1966).

- *Hsiung Shih Art Monthly (Hsiung Shih Meishu)* (Hsiung Shih Meishu Publishing House, Taipei).

- Huang Hai-Ming (curator), *Dis/Continuity: Religion, Shamanism, Nature* (Taipei Fine Arts Museum, Taipei, 1992).

- Lai Tse-han, Ramon H. Myers & Wei You, *A Tragic Beginning: The Taiwan Uprising of February 28, 1947* (Stanford University Press, Stanford, California, 1991).

- Liao Hsu-chang (pub.), *Individualism, The Third Order: A Show of True Strength* (Capital Artistic Centre, Taichung, 1992).

- Lin G-Phone (ed.) *Symposium On 'The Artistic Trends in the Republic of China'* (Taipei Fine Arts Museum, Taipei, 1992).

- Lin Hsing-yueh, *Art in Taiwan: Forty Years' Vicissitudes (Taiwan meishu fengyun 40 nian)* (Independence Evening News Publication, Taipei, 1987).

- Lin Hsing-yueh (curator), *The Art Exhibition Towards Apex* (G. Zen 50 Art Gallery, Kaohsiung, 1993).

- Lin Ping (ed.), *Taiwan Art, 1945–1993* (Taipei Fine Arts Museum, Taipei, 1993).

- Lu Rong-chi (curator), *New Art, New Tribes: Taiwan Art in the Nineties* (Hanart (Taipei) Gallery, 1993).

- Ma Sen, *From Nativist Literature to Nativist Movies* (China Times Publishers, Taipei, 1987).

- Ching-hsi Perng & Chiu-kuei Wang (eds.), *Death in a Cornfield and Other Stories from Contemporary Taiwan* (Oxford University Press, Hong Kong, 1994).

- Robert Storey, *Taiwan: A Travel Survival Kit* (Lonely Planet, Hawthorn, Vic., 1994).

- Caroline Turner (ed.), *Tradition and Change: Contemporary Art of Asia and the Pacific* (University of Queensland Press, St Lucia, 1993).